DIY
String
Art

24 DESIGNS
to create and hang

Jesse DRESBACH

INTERWEAVE.
interweave.com

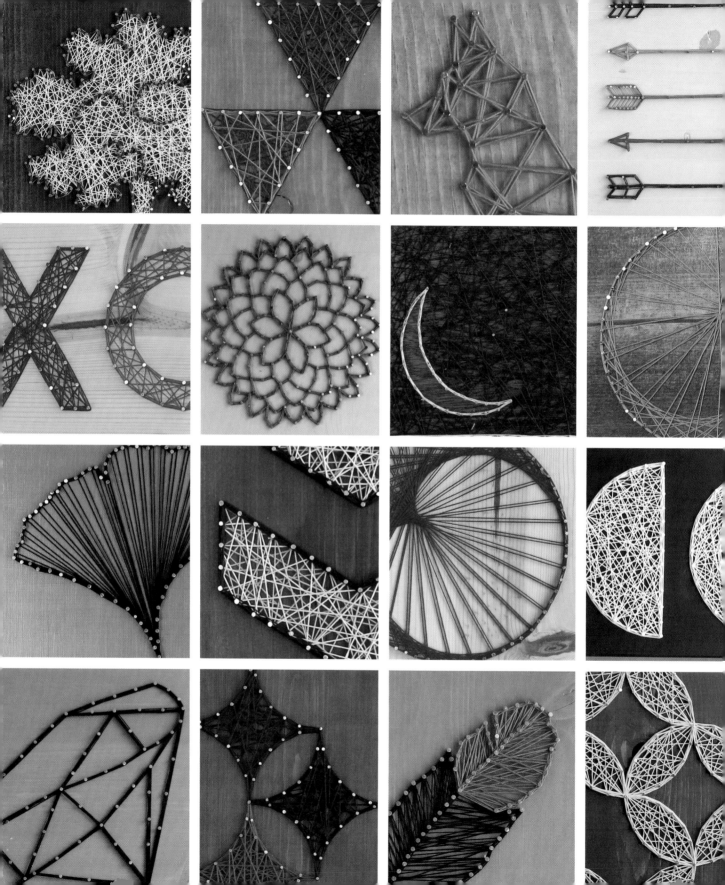

CONTENTS

16 STRING ART PROJECTS

INTRODUCTION

If you grew up in the 1960s and 1970s, you probably remember string art very well. Velvet-covered boards were hung in living rooms across America, portraying sailboats, owls, flowers, and more. String art uses string, thread, or wire to create intricate geometric designs between grids of nails or pins that have been hammered into a board. The origins of this craft date back to the end of the nineteenth century and Mary Everest Boole, who came up with the idea of "curve stitching." She used these activities to help children understand various mathematical concepts. She actually published a book in 1909 called *Philosophy and Fun of Algebra.*

Fast-forward to 1959, when French engineer and mathematician Pierre Bézier was working for an automobile company and needed a more accurate way to describe a curve for manufacture. Influenced by an algorithm created by another French mathematician and physicist, Paul de Casteljau, Bézier's curve could accurately describe any type of curve with only four points. The Bézier curve is commonly used today in computer graphics programs.

When the Bézier curve was publicized in 1962, many artists used this mathematical tool as a source of inspiration. One American artist in particular, John Eichinger, used the Bézier curve to create what he called "string mandalas." Mandala is a Hindu word that means "circle within a circle." Once Eichinger's designs were marketed to the public via popular craft kits in the late 1960s, the craft became an instant favorite.

Trends of course come and go, and string art eventually took a backseat to other popular crafts—until recently. String art is making a bold comeback with seemingly endless new designs, silhouettes and U.S. states being the most common. Modern string art is a bit more flexible, as the designs don't always

have to be strictly mathematically based. This opens up new territory in string art, limiting the projects only to your imagination.

While I wasn't around yet in the 1960s, a few of these relics still adorned the homes of many of my family members, and I was so intrigued by the designs. I've always dabbled in different arts and crafts, jotting down my ideas in a never-ending list of must-try projects. Inspired by a large-scale string art installation done in one home, I decided to explore some new patterns. My first handful of design ideas included the silhouette of a bird, a simple "J" in an Old English font, and a retro throwback of a geometric crescent moon. After much trial and error, I found my rhythm and was hooked. After my home began to overflow with the designs, I listed a few in my Etsy shop, NineRed, to find some new homes for my overstock. I received a great response from the Etsy community and was soon taking orders for more personalized art.

Now it's your turn! If you're reading this, you're clearly just as intrigued by the texture, design, and dimension of string art. This book is full of patterns that help you quickly get to the fun part of the craft: the stringing! With easy-to-follow directions and projects ranging in skill level, there's something for everyone.

One wonderful aspect of using such sturdy materials as wood and nails is that your string art creations will really last. You've probably seen designs online and thought to yourself, "I've got to try that!" Well, there's no time like the present, and I guarantee that after you complete your first string art project, you'll want to create many more.

MATERIALS & TOOLS

Let's get familiar with some of the materials and tools you will need to make string art. Some of these you probably have around the house.

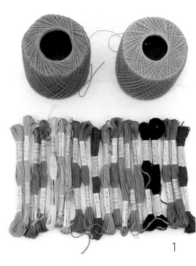

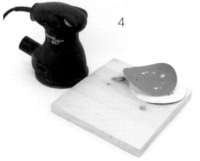

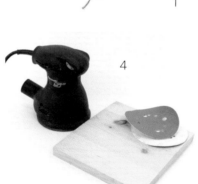

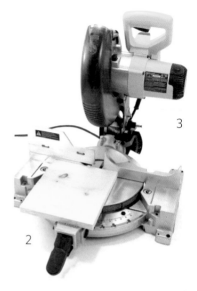

1 **String.** Use craft string, embroidery floss, or crochet thread. For larger projects, it is much easier to work with a spool of crochet thread than to start and stop each time you run out of smaller amounts. DMC is the largest manufacturer of embroidery floss and commonly seen as the industry standard in colors (dmc-usa.com). This book's projects reference the DMC numbers, if you wish to use the same colors shown. Your local craft store should have a DMC chart with numbers and their equivalents in other brands. I commonly use the brand Sullivans, as it's what my nearest store carries.

Always buy more string than you think you'll need—it's relatively inexpensive and beats another trip to the store mid-project.

2 **Wood.** To make the stringing surface, I like to cut different lengths from 1" (2.5cm) thick pine boards that are 8" (20.5cm), 10" (25.5cm) and 12" (30.5cm) wide. Each project will specify further.

You can also purchase wood boards, round wood cuts, and beveled shapes at your local craft store. These usually come unfinished, giving you design freedom.

3 **Saw.** This is for cutting your wood to size. Or, most hardware stores will cut the wood for you to any length you need.

4 **Sandpaper/electric sander.** Before staining or painting your surface, you will need to sand it with medium-grit (120) and fine-grit (220) sandpapers. This can be done by hand or with an electric sander.

5 **Stain or paint.** You can either paint your board or use an oil-based or water-based wood stain, both which come in a variety of colors. Keep in mind that oil-based stain will take at least twenty-four hours to dry. Water-based stain dries quickly enough that you can seal your project shortly after staining.

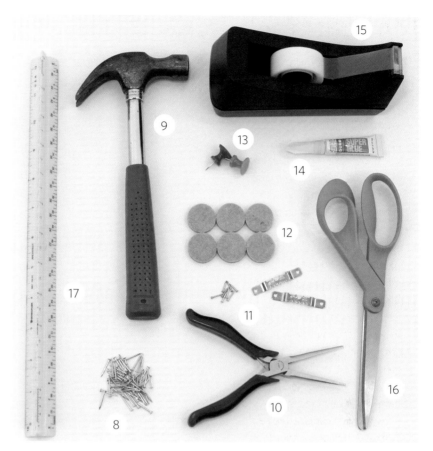

6 **Paint brushes.** Disposable foam brushes work well, or use any brushes you prefer for applying stain, paint, and sealer.

7 **Clear top coat.** I prefer a water-based seal, such as Minwax Polycrylic (satin or semi-gloss). It has far less fumes and makes cleanup a lot easier.

8 **Nails.** My favorite by far are ⅝" (1.6cm) silver nails (#18 × ⅝" [1.6cm]). The choice is yours—just be sure their heads are large enough to catch and hold the string.

9 **Hammer.** You don't need one too big and heavy; a medium- to light-weight hammer is fine.

10 **Needle-nose pliers.** These come in handy for working in areas your fingers have trouble reaching, as well as removing bits of the paper pattern from the nails.

11 **Picture-hanging hardware.** Sawtooth hangers are perfect; kits are available at any hardware store.

12 **Felt furniture pads.** These will help your art sit flush to the wall, as the sawtooth hanger tends to make it stick out a bit.

13 **Push pins.** These are used to help apply some of the nail patterns.

14 **Superglue.** This you will use to seal and secure the string knots. I prefer Loctite Super Glue, though other brands and even clear nail polish will also work.

15 **Tape.** Use standard transparent tape for taping down your pattern for applying nails. Painter's tape is optional when making nail borders.

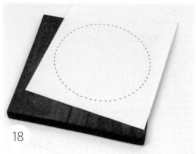

16 **Scissors.** The sharper the better!

17 **Ruler.** For pattern placement and making straight lines.

18 **Photocopy of the pattern.** Enlargement percentages are provided for each project.

PREPARING A BOARD

Select a string art surface

Have a pattern or project in mind before you choose your board, so you can plan the size of the board accordingly. It's a good idea to print out your pattern beforehand to use as a sizing reference.

Look for a surface that won't be terribly difficult to nail into and that can hold the nails in place. My favorite is pine wood; I like the weight, the feel, and that beautiful grain! One thing to look out for when choosing your piece are knots. Personally I like the look of knots, but nailing into one can be a challenge; I've bent nail after nail learning this. However, if you have your board planned out so your pattern works around them, knots can be a nice addition to your art.

Determine the size

Start with a piece of wood that has one of your dimensions already done for you. For example, if you're making a string art design that will be 8" (20.5cm) wide by 24" (61cm) tall, you'll start with a 1" (2.5cm) thick wood board that measures 8" (20.5cm) × 6' (1.8m)—or whatever length you have, longer than 24" (61cm)—and cut it to 24" (61cm) long. **Important note:** When you buy a board—for example, a 1" × 10" (2.5cm × 25.5cm)—the board is never actually 10" (25.5cm) wide; it's usually about 9.5" (24cm). This is because when the board is first rough sawn from the log, it is that size, but the drying and planing of the board reduces it. You'll notice in the projects in this book that I'll show the actual size of the board we are using, but I'll refer to the board by the size it's sold as.

Sand the wood

Once your piece is cut, you'll want to sand the edges to give it a finished look. If you have an electric sander, this is a quick step, but sanding by hand works fine, too. Starting with medium-grit sandpaper, sand the edges and front to smooth.

Follow up with fine-grit sandpaper until your board is clean and smooth to the touch. Be sure to dust the board

You can add some character to a board by sanding random corners and edges heavier, giving it a rustic feel.

clean of sawdust after, so it doesn't get trapped in your stain and create clumps.

Stain or paint and finish

Choose your stain or paint color with your project string colors in mind. Contrasting colors always make for great impact, making your string art more noticeable from a distance. Follow the manufacturer's instructions for your specific stain. A foam brush comes in very handy at this point for application, especially with oil-based stain.

I usually apply two coats of stain. See how you like the color after each coat has been given time to set. Dry time is usually twenty-four hours for oil-based stains and only a few hours for water-based. Again, consult your stain manufacturer's instructions to be sure.

Once your piece is dry, add a clear coat for a more finished look. One coat is usually enough, but take a look after it dries. The nice thing about water-based clear coat is that it dries so fast. If you used paint, many brands have a finish in them already and may not need a clear coat.

You may be tempted to add the hanging hardware at this stage—don't. You'll want the board to sit flush on a table when you are hammering in your nails later.

With the board finished, you're ready to start your artwork.

APPLYING A NAIL PATTERN

Position the printed pattern

Photocopy your pattern of choice from this book, enlarging it at the percentage given. Position the pattern to your liking on your string art surface. If you are using a smaller design and excess paper is getting in the way, loosely trim the pattern to a more manageable size.

If you want to center a pattern, a handy way to do so is to place it all the way to one side of your board, let's say the left. Measure the distance from the right of your board to the right edge of your pattern and divide that number in half to determine how much room should be on each side of the pattern.

Once you've chosen the best spot for your pattern, tape it down.

Start nailing

You'll want to work on a flat, sturdy surface—preferably somewhere you can sit down for all the hammering that's ahead. Be sure the work surface is protected, to prevent any damage from hammering or a nail that goes too far. I like to use a large towel folded over one or two times. This protects my surface as well as muffling the sound a bit. If you are sensitive to sound, you may want to put on some ear plugs—it's hammer time!

The black dots on your pattern represent nails. I find it easiest to nail directly through the printed pattern, then tear off the paper after.

If you would like to be able to reuse your pattern printout, use a thumbtack to push holes into each black dot, then remove the paper. This will mark the pattern on the wood, creating pilot holes for nails.

There's no right or wrong place to start your nails on the pattern; choose what's comfortable for you. I start my nails on the right and work left. Since I hammer with my right hand, and hold the nail with my left, this makes it so my left wrist is not resting on a bed of nails as I work.

Taking your time, pound the nails straight down into the wood, leaving them sticking out about ¼" (6mm) to ½"

Using clear tape to tape down your pattern is helpful in case you can't avoid taping over the black dots.

(1.3cm). Keep in mind you need to leave room for many layers of string to wrap around each nail. If you're using ⅝" (1.6cm) nails, pound them just about halfway in. Don't worry too much about the exact distance—eyeball it as you go, stopping periodically to check that the distance is roughly the same. The strings will blend everything together smoothly.

Double-check your work to ensure all the black dots of the pattern have been nailed. Gently tap any nails that look noticeably higher than the rest, to even them up. Again, the distances don't have to be exact, as when the string is added, you won't notice minor height differences.

Remove the paper pattern

Once everything looks good, tear off the pattern. Grab a side and slowly pull up. You'll see the paper start popping right up and over the nails. Be careful—if you go too fast you'll have lots of shreds to pick out later.

After the bulk of the pattern is removed, you may still have small bits of paper to remove at the base of the nails. Needle-nose pliers are lifesavers here, as they can grab what fingers can't. If there is a tiny piece at the base of the nail that the pliers can't grab, remember the strings will completely cover the base of the nail, hiding the paper.

Now you're ready to string. At this point, the project just looks like a bunch of nails, but once you add the string, your pattern will emerge.

STRINGING BASICS

Choose your string to use

I prefer to use skeins of embroidery floss since there are so many color options; however, for larger projects I opt for crochet thread. Size 10 crochet thread is pretty similar to embroidery floss and also comes in a wide range of colors. The advantage here for larger projects is you won't have to continuously start and stop when you run out of floss.

Most embroidery floss is sold as six-strand floss, since six strands are used to make this thicker thread. Don't separate the strands; just use it as one solid piece. Most small projects take two to three skeins of floss.

Embroidery floss tends to get tangled when I work with it, so I unwrap the entire pack and stretch it across a room before I start. Then I wrap it around either my left hand (since I string with my right) or a cylindrical object such as a cup or a spool. Be careful—if you have cats, they will make this step a hard one!

Secure the anchor knot

To get started, choose a nail in an easily recognizable area of your pattern, such as an edge. Tie a double knot around the nail and trim the excess string. Then comes a very important step: Take your superglue and gently, *very* gently, dab some onto the knot. This secures the

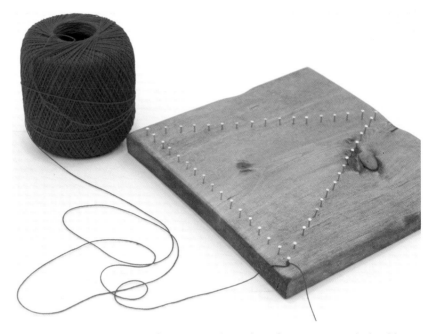

Be sure to seal your knots right after you tie and trim them. Once you start stringing, it's very easy to lose track of where the knot is.

knot to keep it from raveling mid-project or months down the line. Be sure the glue has soaked into the knot (it will look wet).

Do this with every knot you have to make as you complete your project, to keep them secure and prevent strings from coming loose. This is usually the first and last knot of each color applied.

Outline the pattern

Time to connect the dots! First, refer to your pattern (the lines shown represent string) and "draw" the border of your shape with your string.

This important step will help you see which areas should and should not be filled with string. You'll notice on some curves that you won't have to wrap on every nail, as the shape of the pattern will keep it in place.

I'll admit, it can get a little confusing when you are looking at a ton of nails, so keep the pattern printout nearby (or open this book to the pattern page) for reference as you work.

Fill it in

Once you've successfully "drawn" your shape with string, it's time to fill it in. Zigzag your string back and

forth from nail to nail, in any fashion you like. I usually do a random fill-in, dividing larger areas in half with the string until the image has filled in nicely. Each project has more specific details and tips for completing the individual patterns.

If your pattern has any floating shapes that are separated from the main pattern, you may have to repeat the cut/tie/glue/string process for each shape.

Secure the ending knot

Once you are happy with your stringing, choose a nail to tie another double knot to. Trim the excess string and secure with another gentle dab of glue.

Add hanging hardware

After you have filled other shapes and colors, turn your string art over on your protected work surface and attach your picture-hanging hardware according to the package instructions. If using those tiny nails that come with a sawtooth hanger, use a thumbtack to poke two guide holes into the wood, to ease the process. I like to turn the top of the board toward me so that it's easier to work with.

Sign and date the back of your piece, then stand back and admire your work.

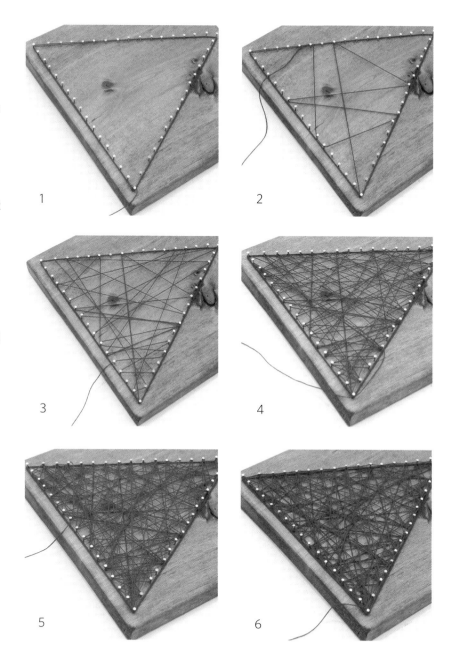

Here you can see the progression of filling in a shape with string, starting with the outline (photo 1) and continuing in a random pattern (photos 2–6) until the desired fill amount is achieved. The amount of string you add is entirely up to you as the artist.

MAKING A NAIL BORDER

For some of the projects, we will be adding a border of nails along all edges of the stringwork surface. This makes inverted projects possible, where the string appears everywhere except the pattern itself. While there are many ways to do this, the method I use requires two thumbtacks, a pen, painter's tape, and a ruler.

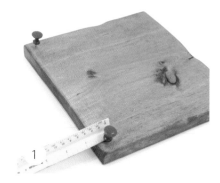

To make:

1 Measure in ½" (1.3cm) from the top and side of your board, to locate a corner. Gently push in a thumbtack there, letting it stick out quite a bit. Repeat for the next corner of your board.

2 This step is optional; you can skip it if you feel comfortable measuring directly onto the board. Line up the edge of a strip of painter's tape to the pin portion of the thumbtacks and press the tape in place to mark a straight edge. Remove the thumbtacks.

3 Using a ruler and a pen, starting from the thumbtack holes that were your corners, measure out and mark your border nail holes. If you choose to skip the tape step, you can usually put your ruler right up to the thumbtacks and do this same technique. I like to distance my border nails ½" (1.3cm) apart.

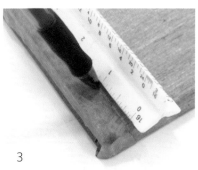

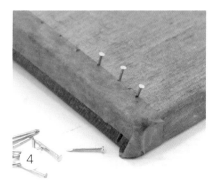

4 Now it's just a matter of hammering nails into your marks, evenly and consistently. Once you're done, if any look slightly crooked, gently tap the side of the nail until it looks straight to the naked eye.

5 Remove the tape to reveal the finished nail border. Repeat for all four edges of your board. Longer edges may need to be done in smaller sections. (A standard foot [30.5cm] is a good section size.) You may find it easiest to tape off all four edges first, then do your nail-hole measuring.

DOUBLE-WRAP TECHNIQUE

A double-wrap border is completely optional, though I recommend it for most projects (this looks especially nice on the circular projects). It's perfect when you need to add a little more emphasis in your design. You can do it in the same color as the rest of your project, or in a contrasting color—you're the artist. For the sake of the tutorial, I'm going to demonstrate on a straight line of nails. This is usually the *last* step done for it to really make an impact, after your shape is filled with string.

To make:

1 Choose a nail on your border to secure your starter knot (see photo 1). Trim and seal your knot.

2 Wrap your string around each nail on the border, as usual (see photos 2.1–2.2). I like to start with the "outside" of the pattern, starting on one side of the nails. Depending on the shape of your pattern, you may not have to wrap around each nail; some shapes will hold the string in place naturally.

3 After you've made a lap around your pattern, come back around and rewrap each nail, on the opposite side. Here's where the real impact happens: come back over your nails, zigzagging in between them (see photos 3.1–

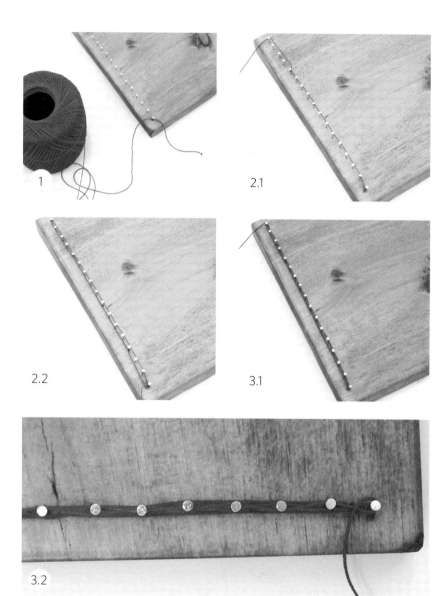

3.2). Do two laps this way. The goal is to put an "X" of zigzagged string between each nail, so that the line really "pops" for the viewer. If you have excess string, feel free to continue wrapping the outside. Be sure to trim and seal your knot once your border is complete.

CREATIVE CONSIDERATIONS

There are so many different styles and variations you can apply to your string art to make it truly unique. Here are a few of my favorites.

Add a contrasting border. Sometimes a string color choice doesn't "pop" against your board like you'd hoped. Adding a simple contrasting color border can really highlight the piece. Black or white string works well for this.

Mix string colors. The color variety in embroidery floss is vast, and wonderful effects can be made by layering different colors of string in the same pattern. You can change the string color at any time by knotting and cutting the old string (sealing the knot) and repeating the stringing process in your new color.

Experiment with nail options. Try using different types and finishes of nails. Copper weather-stripping nails are nice, as are longer brass and gold nails.

Embellish your board. If you get bored with just staining or painting your string art surface, try adding decoupage, where you glue decorative paper to the surface first. Once it's dry, you can seal your board with your clear coat.

Fill around a pattern. A unique take on a string art pattern is to add a border of evenly spaced nails around your entire board and fill the space between the border and the pattern with string, instead of the pattern itself.

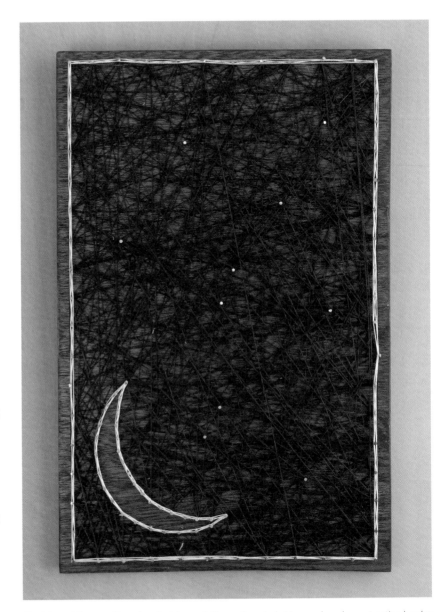

The Moon Memory Board *project (page 34) uses inverted stringwork and a contrasting border.*

TROUBLESHOOTING

Sometimes the unexpected happens. Here are common string art problems and solutions I've found along the way.

The wood you want to work on cracks in the middle of prep.
Occasionally the grain in a piece of wood will cause the board to crack or split in half during the cutting and sanding stage. There are two options at this point: glue or replace. If it's a clean split, you can use wood glue and clamps to bring the board together again. Once it dries, sand the glue residue off and continue. The preferred solution is to replace the piece. This is the safest option, as it eliminates the risk of a re-split when you add your nails.

The wood surface you want to string on contains knots.
While the best solution to this one is prevention, sometimes it can't be helped. While most knots can be nailed into with a good amount of extra force, this can also lead to a bent nail. If that happens, remove the bent nail and start in the same hole with a fresh one. Usually one or two nails in the same hole will get the job done, or close enough to the height of its neighbors. There is one more option if a nail simply refuses to go any deeper and is noticeably higher than the rest: Cut the nail a little shorter (from the tip end) using wire or bolt cutters and superglue the nail into the hole. When the project is done, the string will provide most of the support, and your pattern will be uninterrupted. Again, avoid knots to begin with if you can.

A nail gets bent as you are prepping your board. If it's just a slight bend, you can hammer gently from one side to straighten it out. As long as it's still sturdy, you're good to go. A very bent nail just needs to be removed, and you can do so using the back claw of the hammer or your needle-nose pliers. Try again with a new nail and don't worry—blemishes in the wood not only add character, but usually get hidden by the strings.

Knots can be challenging to your nailing process. If you are able to work around them, however, they can add character to your piece.

You hammer a nail too far into your board. Sometimes the hammer gets a little unwieldy and sends a nail way deeper than the rest. Use the claw of your hammer to gently pull the nail up so it's close to the height of its neighbors.

The nails are difficult to hammer close together. Some patterns get a bit intricate, and working the nail into a tight area can be tricky. Use your needle-nose pliers to hold the nail in place instead of your fingers and hammer as usual.

You run out of wrapping room on a nail. Those little nails can get crowded with string! If it becomes difficult to get multiple layers of string on a nail, try pushing the strings on the nail down toward the board. This usually frees up enough room for another few layers of string.

You try mixing string colors, but the result doesn't look quite right. To mix colors effectively, avoid overfilling your pattern while stringing each color. As you layer in new colors, the fill density will increase as well.

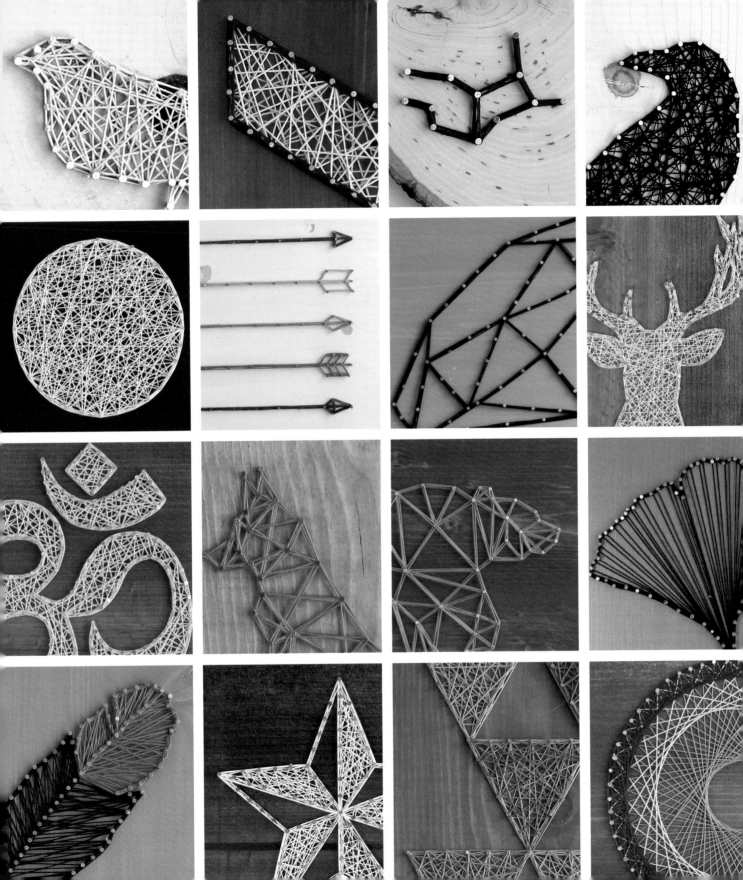

STRING ART PROJECTS

Now that you've got the basics of string art down, the sky's the limit. I've chosen a wide variety of projects for this book, to meet many tastes and skill levels. Each has a "hammer" difficulty rating—from one (easy) to three (challenging). Once you've tried a few projects, you'll really start to get the hang of stringing and get all sorts of ideas and maybe even be inspired to design something new. Remember, you're in the design seat...

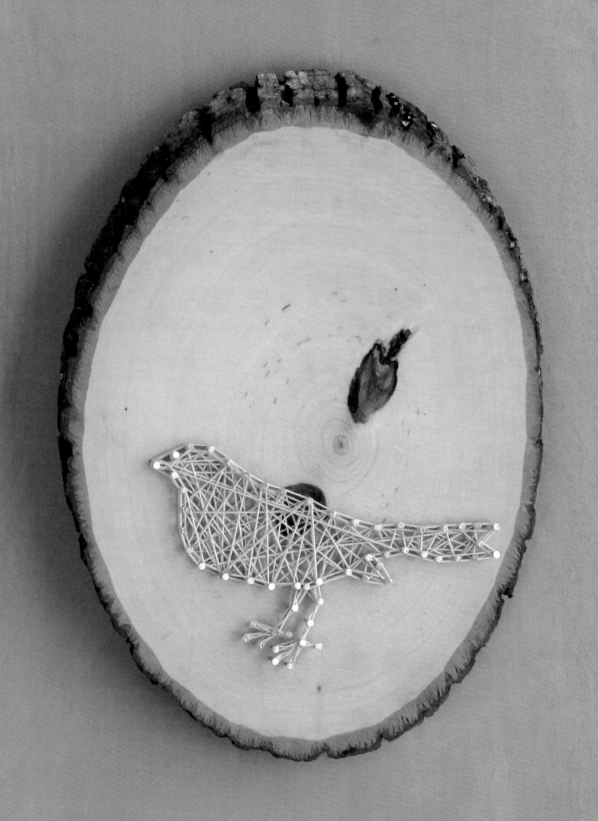

PUT A BIRD ON IT

DIFFICULTY:

When I first started making string art, this little bird was one of the first handful of ideas I had to try out. It's so simple and cute and the perfect accent for any room. I chose to use a natural basswood round wood cut (or tree slice, as I call them) for this project, an item available in most craft stores.

Materials

Basswood round, large size

⅝" (1.6cm) silver nails

Embroidery floss in 1 color (Shown: DMC 964/Light Seagreen)

Photocopy of pattern (page 20)

Picture-hanging hardware

2 felt furniture pads

Tools: Hammer, needle-nose pliers

Basic supplies: Superglue, scissors, transparent tape

Techniques Used

Applying a nail pattern (page 9)

Stringing basics (pages 10–11)

Double-wrap technique (page 13)

Finished Size (h × w)

10" × 7" (25.5cm × 18cm)

PUT A BIRD ON IT

1 Photocopy and cut out the bird pattern, leaving a margin of about an inch (2.5cm) or so on all sides. This makes it much easier to position on the wood. Position your bird as you like and tape the pattern to your wood cut.

2 Hammer the nails into the pattern, then remove the paper and debris.

3 Tie on and string the outline of the bird, making sure to secure your starter knot with superglue. I like to take care of the feet of the bird at this point, too, using the double-wrap technique for emphasis. Refer carefully to the pattern shown, as the feet can get a little tricky.

4 Zigzag to fill in to completion. I usually need one skein of floss for this project, but I always buy two. You never know when you'll experience a tangle beyond recovery or feel like you need a little more fill. Don't forget to glue to secure your knots.

5 Attach the picture-hanging hardware to the upper back side, as well as the two felt pads to the lower back side. Sign, date, and enjoy!

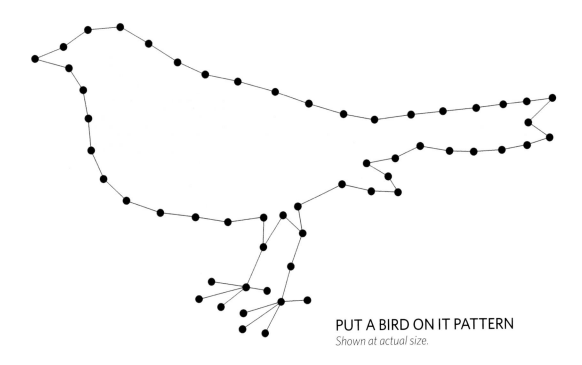

PUT A BIRD ON IT PATTERN
Shown at actual size.

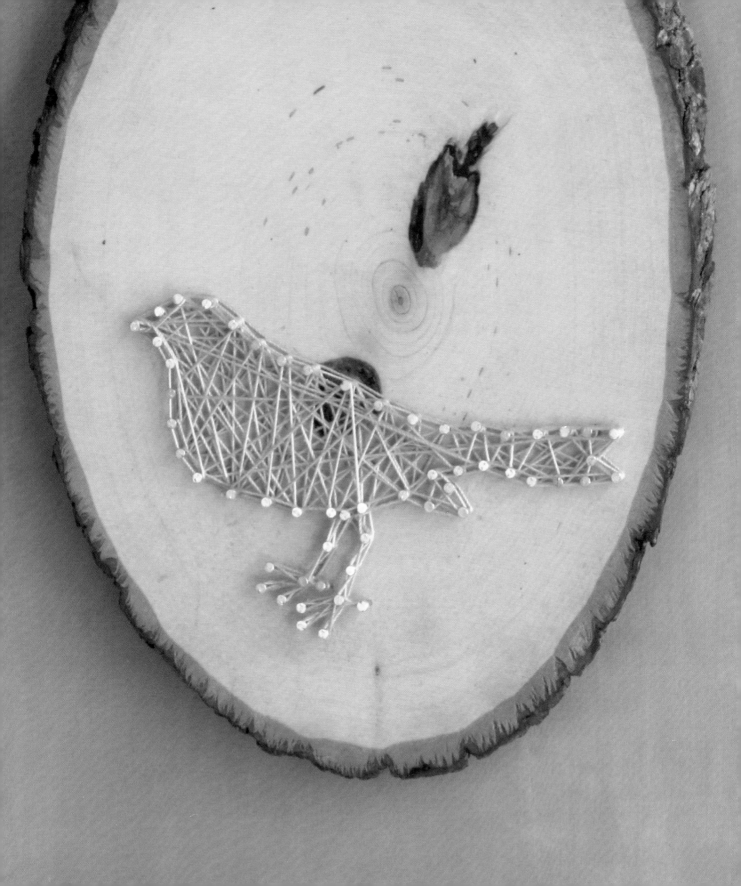

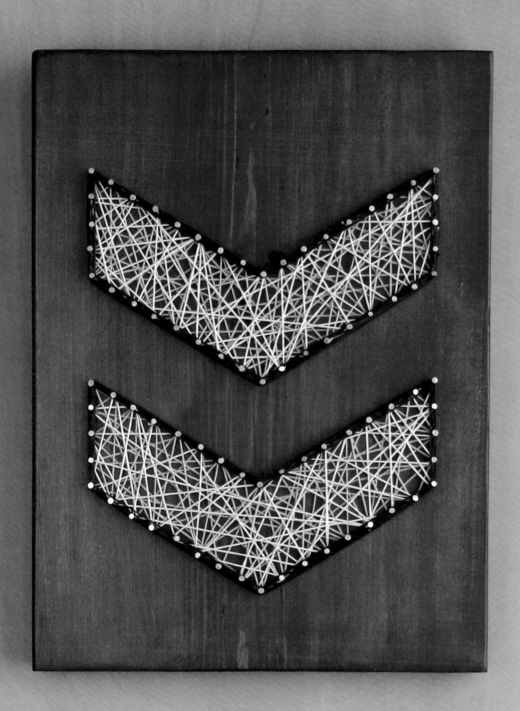

CHEVRON

DIFFICULTY: 🔨

If you came to my house, you'd definitely notice a few chevrons here and there. What can I say? I love the pattern, so I just had to try a string art version. For this project, I kept it to two simple sections, but you can use this basic shape in so many ways. Make multiple copies and connect them if you want to fill a larger space. Simply trim the pattern down and connect the dots on the vertical ends. (A useful thumbtack trick is shown in the *Triangle Tiles* project on page 88.)

Materials

Pine board: 1" × 10" (2.5cm × 25.5cm), cut to 12" (30.5cm) long and stained (Shown: Minwax Water-Based Wood Stain in Island Water)

⅝" (1.6cm) silver nails

Embroidery floss in 2 colors (Shown: DMC 3845/Medium Bright Turquoise, 964/Light Seagreen)

Size 10 crochet thread in 1 color, for border (Shown: Navy blue)

Photocopy of pattern (page 24)

Picture-hanging hardware

2 felt furniture pads

Tools: Hammer, needle-nose pliers

Basic supplies: Superglue, scissors, transparent tape, ruler

Techniques Used

Preparing a board (page 8)

Applying a nail pattern (page 9)

Stringing basics (pages 10–11)

Double-wrap technique (page 13)

Finished Size (h × w)

12" × 9.5" (30.5cm × 24cm)

CHEVRON

1 You won't necessarily need to trim this pattern from the paper like usual, as the paper's edges can help you center it on your board. One of my tried-and-true ways to roughly center a pattern is to place your pattern all the way to the left of the board and measure the distance from the right side of your board to the right side of your pattern edge. Divide that distance in half and you know how much space should be on each side. Tape your pattern down once you are happy with its position.

2 Hammer through your pattern as usual and remove.

3 Tie on (securing your knot with glue) and outline the edges of each shape.

4 Fill the shape as usual, with a random zigzag pattern. If you are doing multiple colors like I did, it's nice to do the colors in the same order for both shapes. I unwrapped the entire skein of floss, stretched it across the room, folded it in half, and cut. Then I did half a skein of each color, in each shape, in the same order. Tie off and glue your knots.

5 I went ahead and added a double-wrap border in navy blue to really make it shine.

6 Attach your picture-hanging hardware to the upper back and pads to the lower back, sign it, date it, and that's a wrap! Little string art joke there...

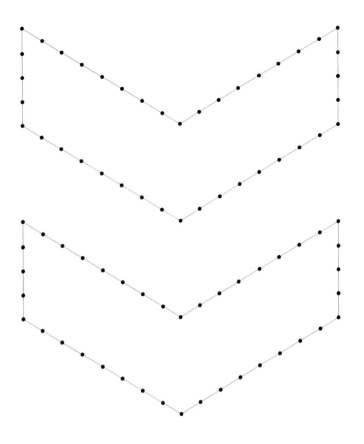

CHEVRON PATTERN
Enlarge at 200%.

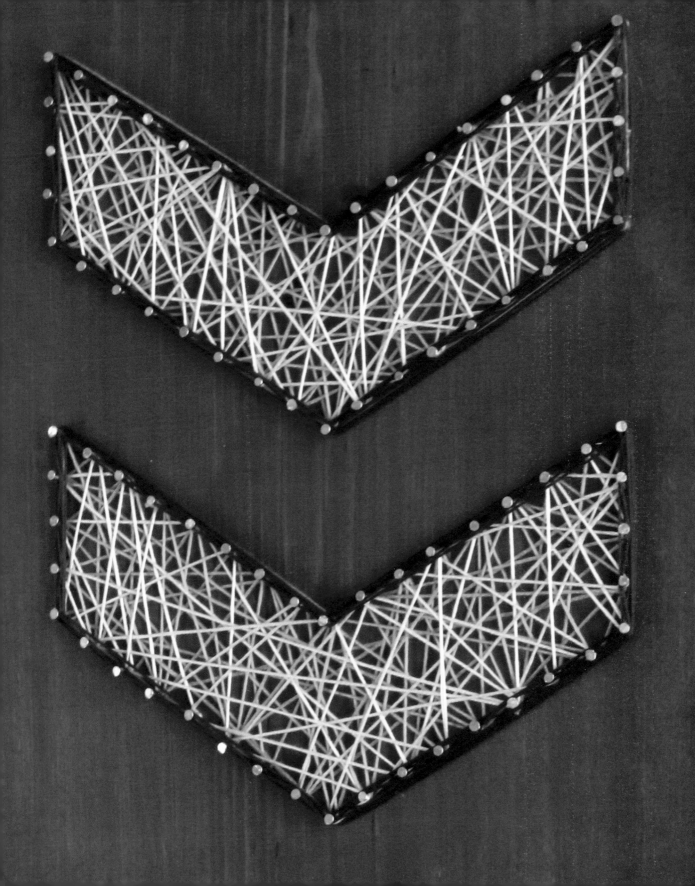

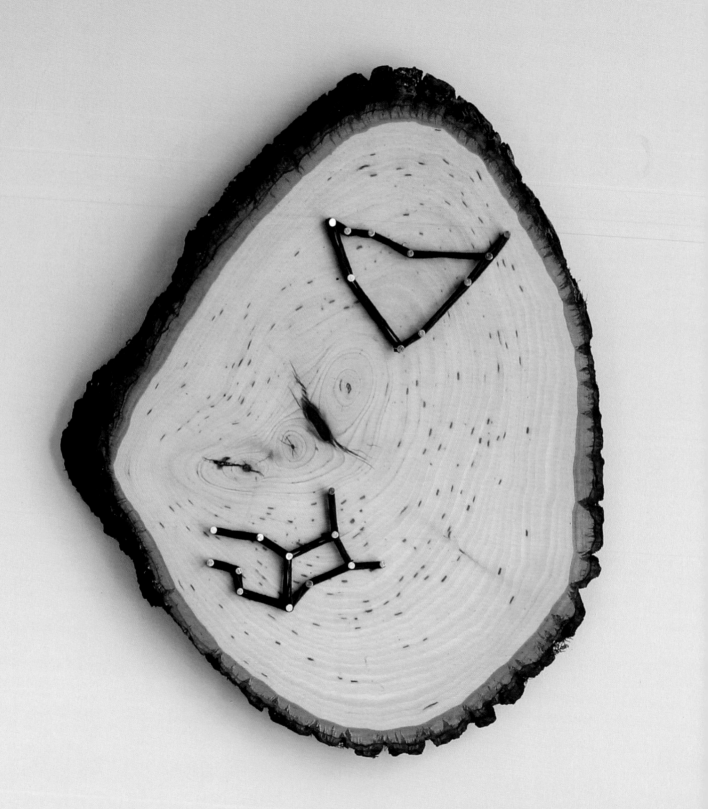

ZODIAC CONSTELLATIONS

DIFFICULTY:

If there's one shape that lends itself best to string art, it's a constellation. The nails work perfectly as little stars! With so many to choose from, I thought the twelve zodiac constellations would be the most fun. This quick project makes a great personalized gift. Here, I've chosen to make a couples' constellation piece, pairing Virgo and Capricorn.

Materials

Basswood round, large size

⅝" (1.6cm) silver nails

Embroidery floss in 1 color (DMC shown: 336/Navy Blue)

Photocopy of pattern(s) (page 28)

Picture-hanging hardware

2 felt furniture pads

Tools: Hammer, needle-nose pliers

Basic supplies: Superglue, scissors, transparent tape

Techniques Used

Applying a nail pattern (page 9)

Stringing basics (pages 10–11)

Double-wrap technique (page 13)

Finished Size (h × w)

11" × 9" (28cm × 23cm)

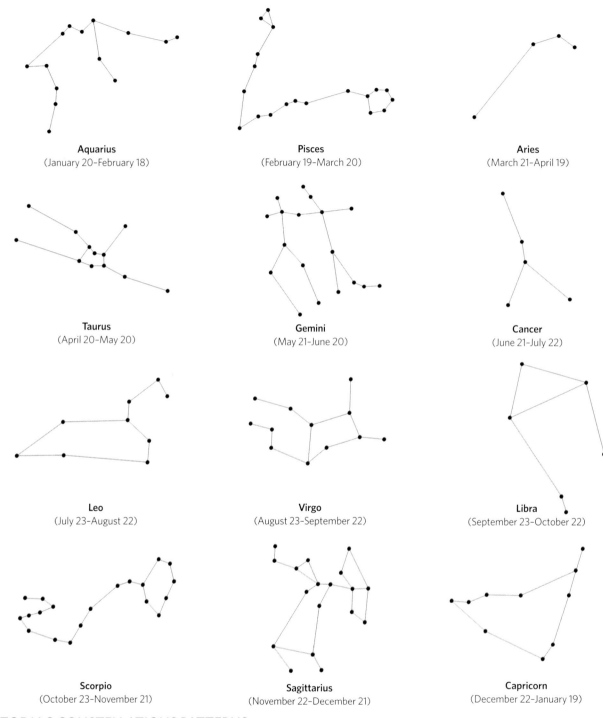

Aquarius
(January 20–February 18)

Pisces
(February 19–March 20)

Aries
(March 21–April 19)

Taurus
(April 20–May 20)

Gemini
(May 21–June 20)

Cancer
(June 21–July 22)

Leo
(July 23–August 22)

Virgo
(August 23–September 22)

Libra
(September 23–October 22)

Scorpio
(October 23–November 21)

Sagittarius
(November 22–December 21)

Capricorn
(December 22–January 19)

ZODIAC CONSTELLATIONS PATTERNS
Enlarge at 200%.

ZODIAC CONSTELLATIONS

1 Trim your patterns down to a manageable size and position them on your tree slice or board. You'll notice the name of your constellation is under it, demonstrating its proper orientation. Tape your pattern in place. **Note:** This pattern can easily be enlarged beyond the suggested percentage if desired.

2 Hammer your nails everywhere there is a dot on your constellation, then remove the paper and debris.

3 Choose your floss color and tie it onto your pattern, securing your knot with glue. Refer to the pattern again to be sure you connect the right nails. Since this doesn't take much string at all, I chose to double-wrap the design. Seal your knots with superglue.

4 Attach your picture-hanging hardware to the upper back and felt pads to the lower back. Sign and date your work and you're done!

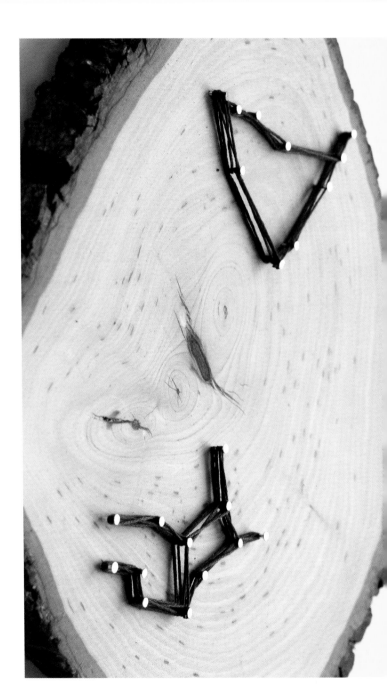

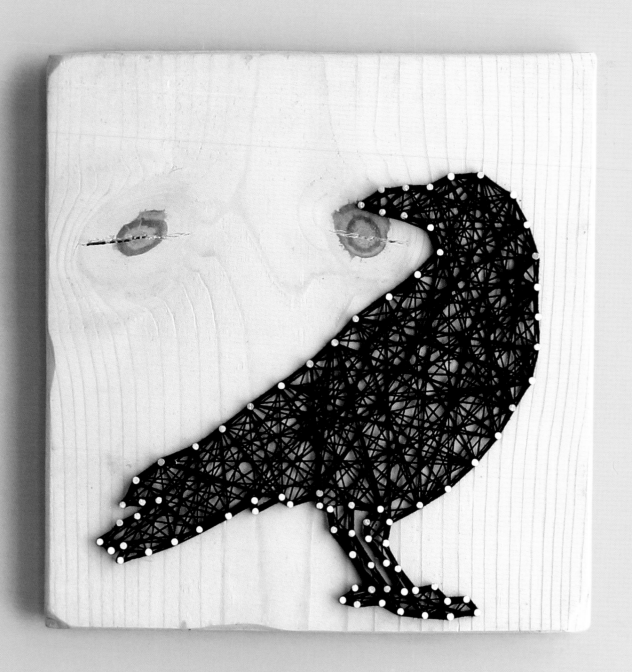

THE RAVEN

DIFFICULTY:

The raven is one of the most intelligent and intriguing birds. They are social, clever, and really good problem-solvers. Their silhouette is instantly recognizable and converts very well to string art. You can use a spool of black crochet thread on this one, which makes for uninterrupted stringing. While this would naturally make a great piece for autumn décor, it's stylish enough to stay up year-round.

Materials

Pine board, 1" × 10" (2.5cm × 25.5cm), cut to square and painted with yellow acrylic craft paint (see step 1)

⅝" (1.6cm) silver nails

Size 10 crochet thread in black

Photocopy of pattern (page 32)

Picture-hanging hardware

2 felt furniture pads

Tools: Hammer, needle-nose pliers

Basic supplies: Superglue, scissors, transparent tape

Techniques Used

Preparing a board (page 8)

Applying a nail pattern (page 9)

Stringing basics (pages 10–11)

Finished Size (h × w)

9.5" × 9.5" (24cm × 24cm)

THE RAVEN

1 For this board, I went with paint instead of stain. To get the grain to show through, I watered down the yellow paint in a bowl first, then brushed a few coats on until it looked right.

2 Trim your pattern to a manageable size. Position it on your board and secure it with tape. I prefer the lower right corner.

3 Tie your thread onto a nail, sealing the knot with glue. Start with the outline of the raven, making it easier to see what areas to fill. Reference your pattern page to be sure you connect the correct nails. Keep an eye on the gap between the two legs; that will need to stay empty.

4 Zigzag your string randomly until you are happy with the density. The feet on this pattern are based on an actual silhouette and will seem strange at first. Don't worry; once you're done they will look right. Tie off and seal your knot with glue.

5 Attach your picture-hanging hardware to the back. Be sure to put your two felt pads on the lower back-side corners, so your art will sit flush to the wall. Sign and date your work.

THE RAVEN PATTERN
Enlarge at 200%.

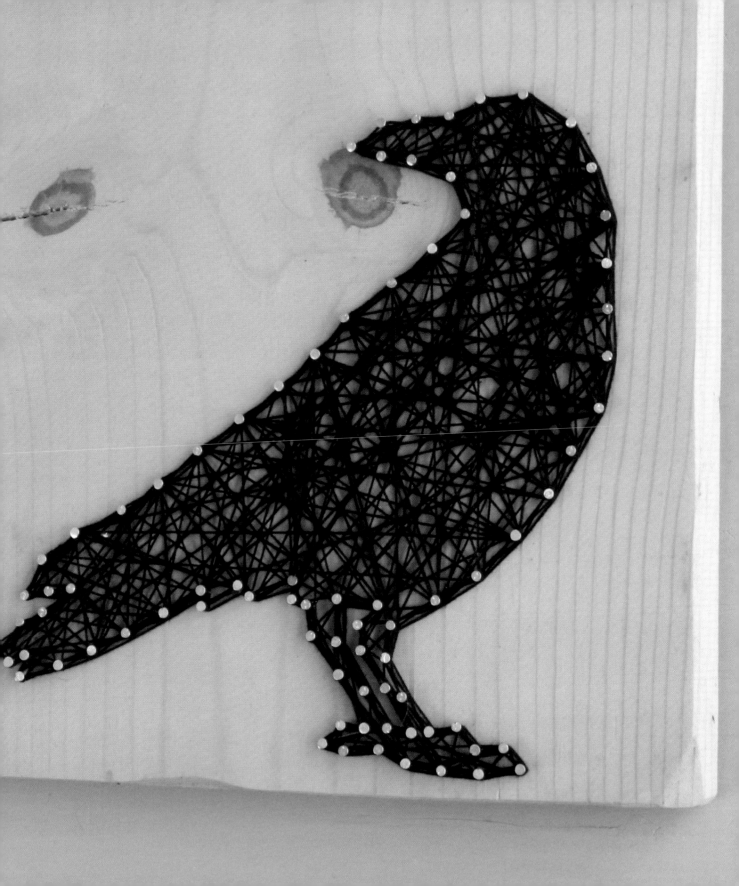

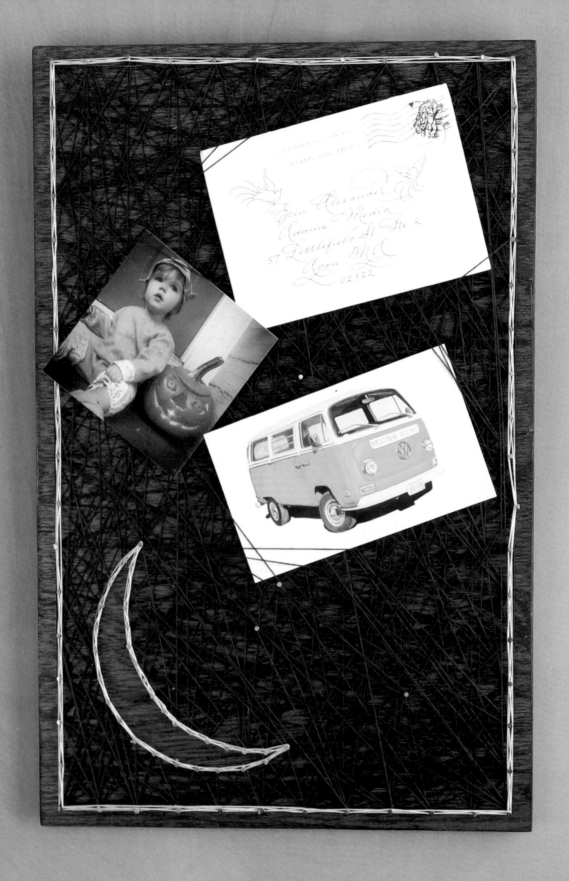

MOON MEMORY BOARD

DIFFICULTY: 🔨

Here's a different take on string art, where it becomes more of a functional piece than a showpiece: a memory board! The idea here is the same as a ribbon memory board, where the tension of the ribbon (or string, in this case) gives just enough strength to hold lightweight notes, mementos, and reminders. I strongly suggest you use a spool of crochet thread for at least the fill on this piece—it's going to take a lot.

Materials

Plywood plank, 12" × 18" (30.5cm × 45.5cm), stained (Shown: Minwax Wood Finish in Dark Walnut)

⅝" (1.6cm) silver nails

Size 10 crochet thread in 2 colors (Shown: Navy blue and white)

Photocopy of pattern (page 36)

Picture-hanging hardware

2 felt furniture pads

Tools: Hammer, needle-nose pliers

Basic supplies: Superglue, transparent tape, painter's tape, ruler, thumbtacks, pen

Techniques Used

Preparing a board (page 8)

Applying a nail pattern (page 9)

Stringing basics (pages 10–11)

Making a nail border (page 12)

Double-wrap technique (page 13)

Finished Size (h × w)

18" × 12" (45.5cm × 30.5cm)

MOON MEMORY BOARD

1 Start by putting a nail border around the entire board. I chose to space them 1" (2.5cm) apart since the board is pretty big.

2 Trim your moon pattern to the shape you'd like, in the phase you want. I went for crescent moon here, which is the two left arcs on the pattern. Position the moon in your desired location, making sure to leave room between the moon and the edge; at least an inch (2.5cm) should be fine. Secure your pattern with tape.

3 Nail through your pattern, removing the paper and debris afterwards. Add a few random nails throughout the fill (sky) area—these will not only help keep the longer sections of string tight, but will look like stars.

4 Start stringing the sky first—navy blue in this case. Tie on (sealing your knot) and zigzag randomly throughout the entire piece. This is where a spool of string comes in handy; you'll want to cover the sky thickly with string. You can loop onto the star nails now and then to help vary your lengths of string, while adding to the overall random appearance.

5 Once the fill is to your liking, tie off and seal your knot. Outline the moon and the border with the white string, using the double-wrap technique.

6 Attach your picture-hanging hardware. If your board is on the wider side, you may want to attach two sets of hardware to the back. Add your felt pads to the lower back side, then sign and date your work.

7 Add notes, photos, and mementos! To attach papers to this board, just nestle the corners of the paper in between the strings. The tension in the filler should keep them snugly in place.

MOON MEMORY BOARD PATTERN
Enlarge at 200%.

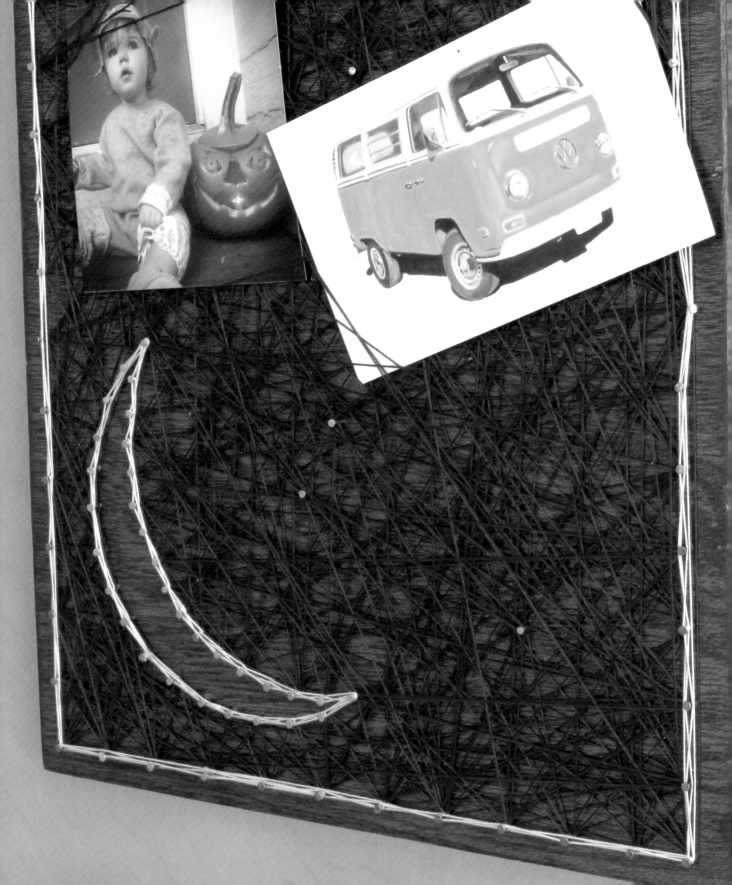

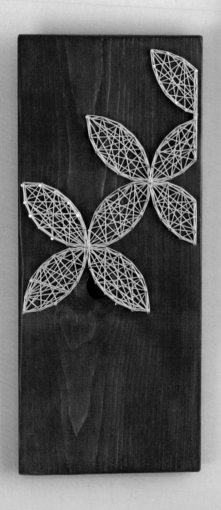
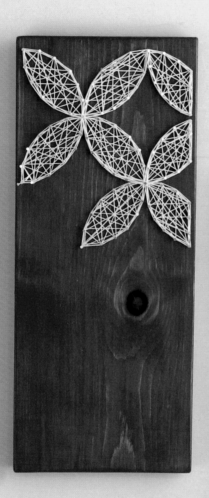
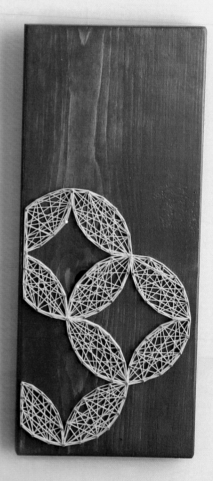

OVERLAPPING CIRCLES

DIFFICULTY:

Geometric patterns are my favorites to do in string art. This is a classic overlapping circle pattern, which makes the perfect retro throwback piece. You can build on with this pattern, too, adding as many boards as you like. They really make an impact arranged as a set. Plus, there isn't really a top or bottom with these, so you can hang them any direction you like. Sometimes I see the circles, and other times I see flower petals. Which do you see?

Materials

3 pine boards: 1" × 8" (2.5cm × 20.5cm), each cut to 17" (43cm) long and stained (Shown: Minwax Water-Based Wood Stain in Island Water)

⅝" (1.6cm) silver nails

Embroidery floss in 3 colors (Shown: DMC 725/Medium Light Topaz, 726/Light Topaz, 972/Deep Canary)

3 photocopies of pattern (page 40)

3 sets of picture-hanging hardware

6 felt furniture pads

Tools: Hammer, needle-nose pliers

Basic supplies: Superglue, scissors, transparent tape

Techniques Used

Preparing a board (page 8)

Applying a nail pattern (page 9)

Stringing basics (pages 10–11)

Finished Size (h × w)

17" × 7.5" (43cm × 19cm) each

OVERLAPPING CIRCLES

1 For this project we use the same pattern three times, but it's easy to get confused which is which. The pattern has letters inside each shape: A, B, and C. I like to shade in all the A's on one sheet, all the B's on another, and so on. This keeps things clear.

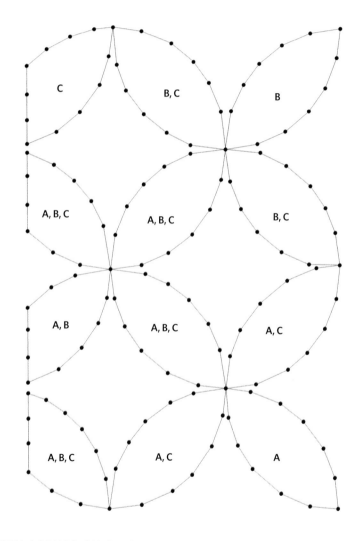

OVERLAPPING CIRCLES PATTERN
Enlarge at 200%.

2 Attach your patterns to your boards in the desired location. You'll notice the flat edge where the shapes are cut, on the left of the pattern. Line up that side with the edge of the board, about ¼" (6mm) to ½" (1.3cm) from the edge. If you wish to copy mine exactly, you can see in boards A and B that I turned the pattern upside down and placed it on the top left. C is positioned on the bottom right.

3 Begin adding nails to your pattern, paying attention to which pattern sheet you are working on (A, B, or C). You are the designer and can add and subtract shapes as you see fit. There will be a good amount of string layers on these, so don't go too deep with the nails. Remove the paper and any debris.

4 Tie on (sealing your knot) and begin the outline of your pattern. Since the shapes are connected at the corners, you won't have to tie off and on for each shape. Fill each shape with random zigzag patterns. I used just under three skeins of floss per board. Be sure to seal your knots.

5 Once you have finished all three boards, lay them out to decide the orientation of your boards. Then attach your picture-hanging hardware and felt pads. Sign and date.

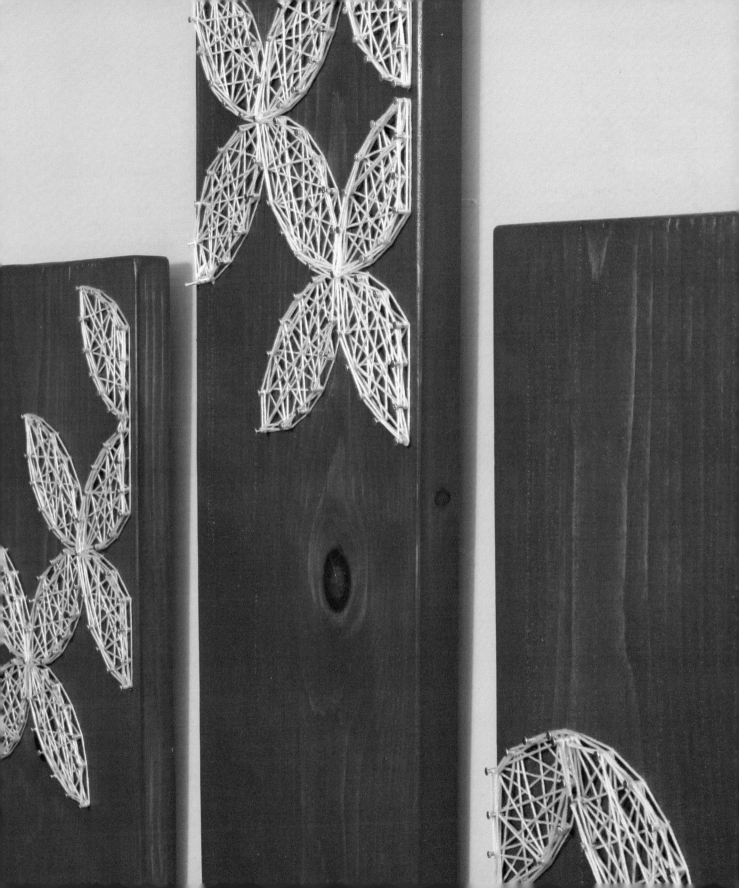

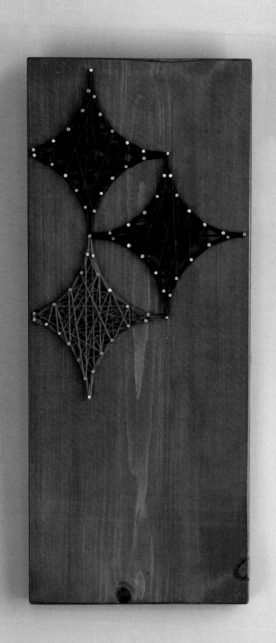
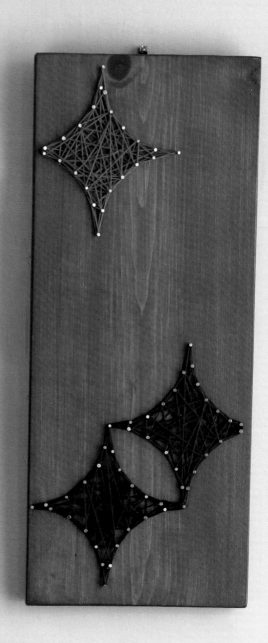

NEBULA

DIFFICULTY:

Here's another take on the geometric pattern we used in the *Overlapping Circles* project. This is the same pattern, only the inverse fill. These shapes definitely remind me of shining stars, so the name "Nebula" was perfect for this project. Again, the sky is the limit with patterns like these—you can add onto them where you see fit, giving you plenty of design freedom.

Materials

2 pine boards: 1" × 8" (2.5cm × 20.5cm), each cut to 17" (43cm) long and stained (Shown: Minwax Water-Based Wood Stain in Green Tea)

⅝" (1.6cm) silver nails

Embroidery floss in 4 colors (Shown: DMC 3804/Dark Cyclamen Pink, 915/Dark Plum, 550/Very Dark Violet)

2 photocopies of pattern (page 44)

2 sets of picture-hanging hardware

4 felt furniture pads

Tools: Hammer, needle-nose pliers

Basic supplies: Superglue, scissors, transparent tape

Techniques Used

Preparing a board (page 8)

Applying a nail pattern (page 9)

Stringing basics (pages 10–11)

Finished Size (h × w)

17" × 7.5" (43cm × 19cm) each

NEBULA

1 Start by deciding which board will have which shapes. Shade in the shapes on your pattern, to help keep it clear what goes where. For one board, I used all three interior star shapes (1, 2, and 3), and for the other, I trimmed the third star and positioned it farther away on the board. The design is totally up to you. Tape your pattern to your board. Make sure none of the nail marks are too close to the edge; I like to leave about a ¼" (6mm) to ½" (1.3cm) gap.

2 Nail through your pattern to create your design. Remove the paper and debris.

3 Choose which colors go where and tie on (sealing your knot) to being stringing. I recommend not starting on a nail that will be shared with the other shapes, as the knot takes up more space on the nail. Begin with the outline of the shape, following with the fill. The shapes fill pretty quickly on this one. Be sure to seal every knot you make.

4 Once your shapes are finished, lay out your boards to decide their orientation. Attach the picture-hanging hardware to the back, as well as the felt pads. Sign and date your work and choose where to display your starry art!

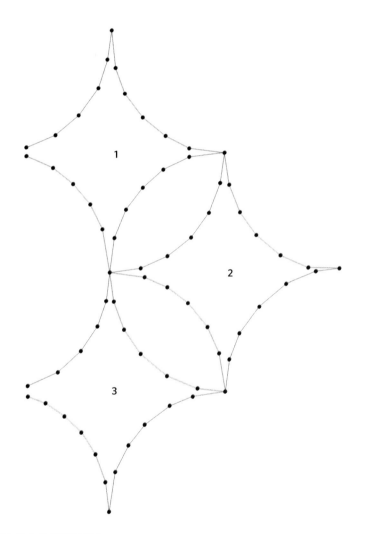

NEBULA PATTERN
Enlarge at 200%.

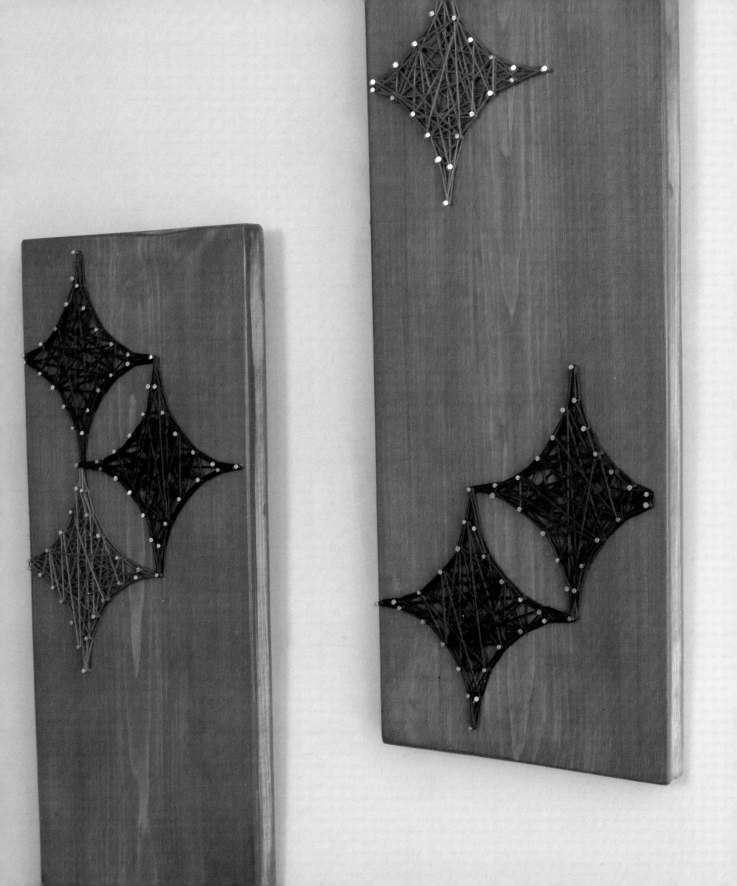

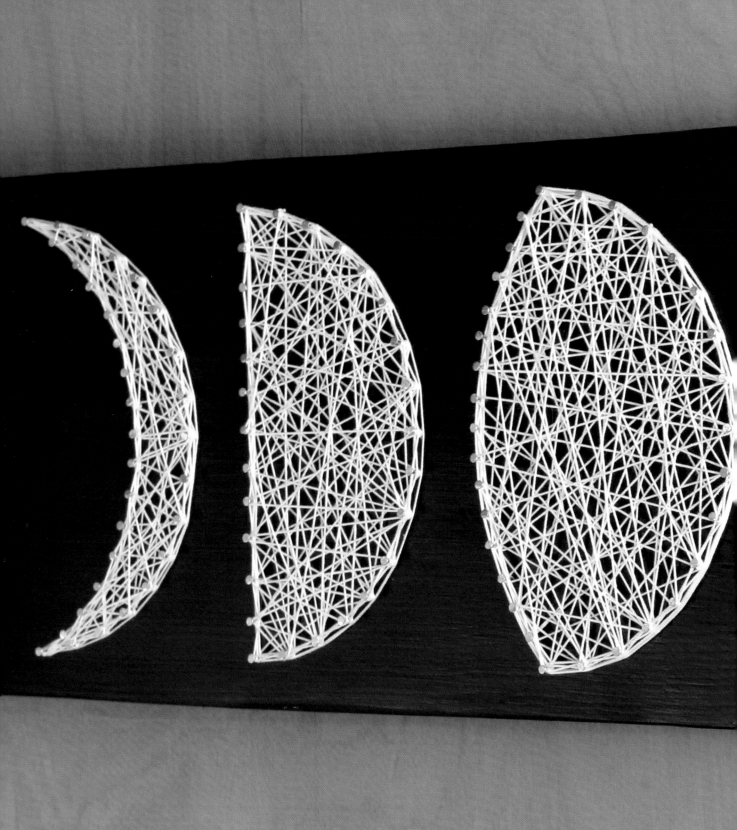

PHASES OF THE MOON

DIFFICULTY: 🔨

When planning a moon project, I knew it couldn't just be a circle because there would be nothing to point out that it's meant to be the moon. Having all its phases in this piece really highlights the intended design. The white string on black stain is so striking! Just for the record, the names of the phases shown, from left to right, are waxing crescent, first quarter half, waxing gibbous, full moon, waning gibbous, last quarter half, and waning crescent.

Materials

Pine board: 1" × 8" (2.5cm × 20.5cm), cut to 38" (96.5cm) long and stained (Shown: Minwax Express Color in Onyx)

⅝" (1.6cm) silver nails

Size 10 crochet thread in 1 color (Shown: White)

7 photocopies of pattern (page 49)

2 sets of picture-hanging hardware

4 felt furniture pads

Tools: Hammer, needle-nose pliers

Basic supplies: Superglue, scissors, transparent tape, painter's tape, ruler, thumbtacks, pen

Techniques Used

Preparing a board (page 8)

Applying a nail pattern (page 9)

Stringing basics (pages 10–11)

Finished Size (h × w)

7.5" × 38" (19cm × 96.5cm)

PHASES OF THE MOON

1 Start by preparing your patterns. You'll notice that all the moon phases have been incorporated into one pattern. Make several copies of the pattern and shade in a different phase on each pattern; this eliminates any chance of putting nails in the wrong holes. Then, cut out each phase from its pattern. Cutting them out makes it much easier to position them equally spaced.

2 Measure your board and start with the full moon in the center. On my 38" (96.5cm) board, this put the center of my full moon at 19" (48.5cm). Be sure it's centered from top to bottom as well and tape down your pattern.

3 Add the rest of the phases by measuring to each side from the full moon. I spaced my phases 1" (2.5cm) apart. When spacing, I measure from the nail marks on the pattern. This is why cutting the phases out helps, because as the phases get smaller, they take up less space. If we were to evenly space the full pattern, the spacing would get farther apart. Continue working until all the phases have been secured to your board.

4 Begin nailing! Because I hammer with my right hand and hold the nails with my left, I like to start on the right side of the board, working my way left. This way my left

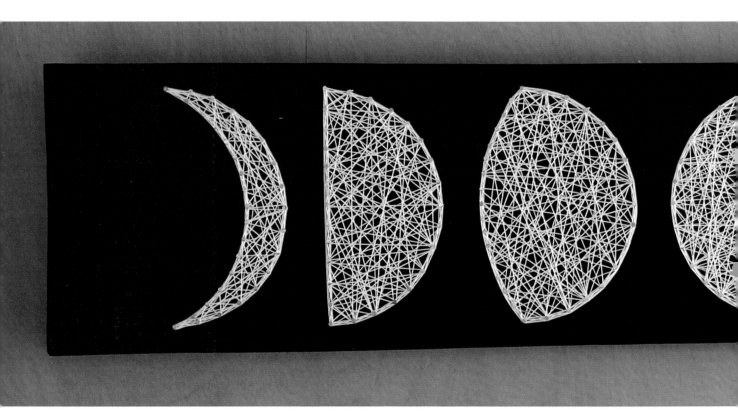

hand is not resting on nails the whole time. Once your phase designs are complete, remove the pattern paper and debris.

5 Tie on with your white crochet thread, sealing the knot with glue. Fill each phase, trying to keep the density of your strings consistent throughout each. Be sure to seal your knots. Don't worry, you can always add more string later if one phase seems less dense.

6 Since this project is so wide, using two sawtooth picture hangers will keep it from going crooked on your wall. To position the hangers on the back side, I like to measure 4" (10cm) in from the edge and 1" (2.5cm) down from the top. Don't forget to put felt pads on the lower back corners to keep it sitting flush. Sign and date your work. This was a big one!

PHASES OF THE MOON PATTERN
Enlarge at 200%.

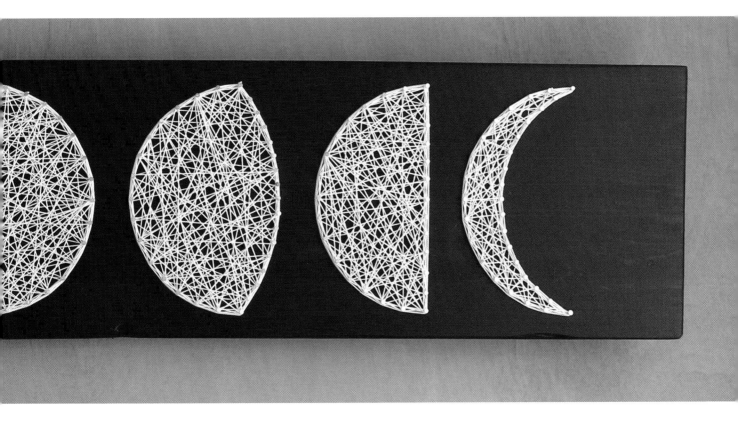

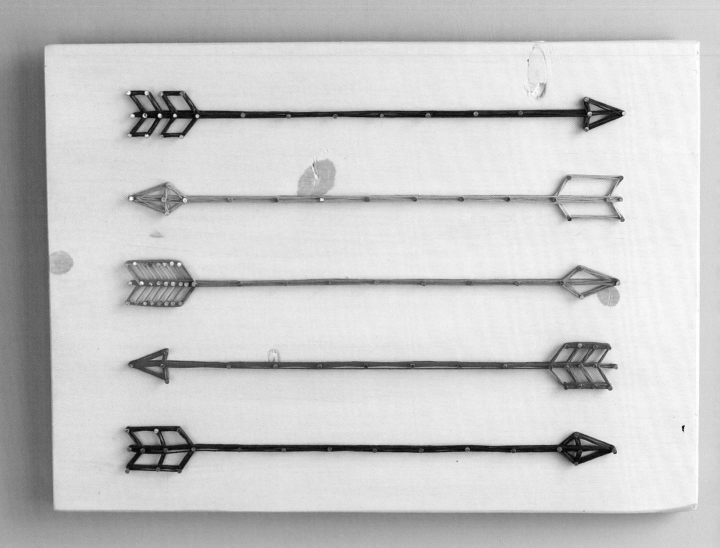

FOLLOW YOUR ARROW

DIFFICULTY:

Here's a fun, simple shape that looks fantastic in string: the humble arrow. The project variations you could do with this pattern are endless; I'm choosing to do a stack of five. What's fun about this project is that all the arrows appear the same at first glance, but upon closer inspection you can spot the differences in the arrow heads and tails.

Materials

Pine board: 1" × 12" (2.5cm × 30.5cm), cut to 16" (40.5cm) long and painted with white acrylic craft paint (see step 1)

⅝" (1.6cm) silver nails

Embroidery floss in 5 colors (Shown: DMC 924/Very Dark Gray Green, 415/Pearl Gray, 729/Medium Old Gold, 891/Dark Carnation, 3787/Dark Brown Gray)

5 photocopies of pattern (page 52)

Picture-hanging hardware

2 felt furniture pads

Tools: Hammer, needle-nose pliers

Basic supplies: Superglue, scissors, transparent tape, ruler, pencil

Techniques Used

Preparing a board (page 8)

Applying a nail pattern (page 9)

Stringing basics (pages 10–11)

Double-wrap technique (page 13)

Finished Size (h × w)

11.25" × 16" (28.5cm × 40.5cm)

FOLLOW YOUR ARROW

1 I wanted a whitewashed look for my board for this project, so I watered down white paint. I applied about three layers, making sure to wipe off any drips on the sides.

2 Cut out your arrows so they are easier to work with. Place the center arrow first. Measure your board from top to bottom and find the middle—for me this was just above 5.5" (14cm). This is where the center line of your middle arrow will go. To be sure it's straight, make sure to measure from the edge of your board to the center line of your arrow in two different spots. The farther apart, the better. Be sure the arrow is centered from the sides as well. Tape the middle arrow to the board.

3 Working from the center arrow, measure equally outward to add the rest. Choose your spacing distance and be sure to measure again from two places on the arrow to the next arrow, to keep them parallel. I chose a spacing distance of about 1¾" (4.5cm) and to alternate the direction each arrow pointed. Tape down the arrows.

4 Once your arrows are attached and look good from a distance, hammer nails through the pattern. This is when you can customize the heads and tails. Draw your ideas in pencil on the pattern, connecting the dots and circling which nail marks you'll need to hit. Once you've finished adding the nails, remove the paper and debris.

5 Add the string, remembering to seal your knots. These arrows won't take much string at all, and they are definitely a candidate for the double-wrap technique (I may have even done a triple-wrap at times). I recommend tying onto a nail in the center, as the head and tail of each arrow end up with a lot of layers. I chose to only do outlines on this project, though you could easily fill the arrow head and tail with zigzagging string if you like.

6 Attach picture-hanging hardware and felt pads and sign and date your work.

FOLLOW YOUR ARROW PATTERN
Enlarge at 200%.

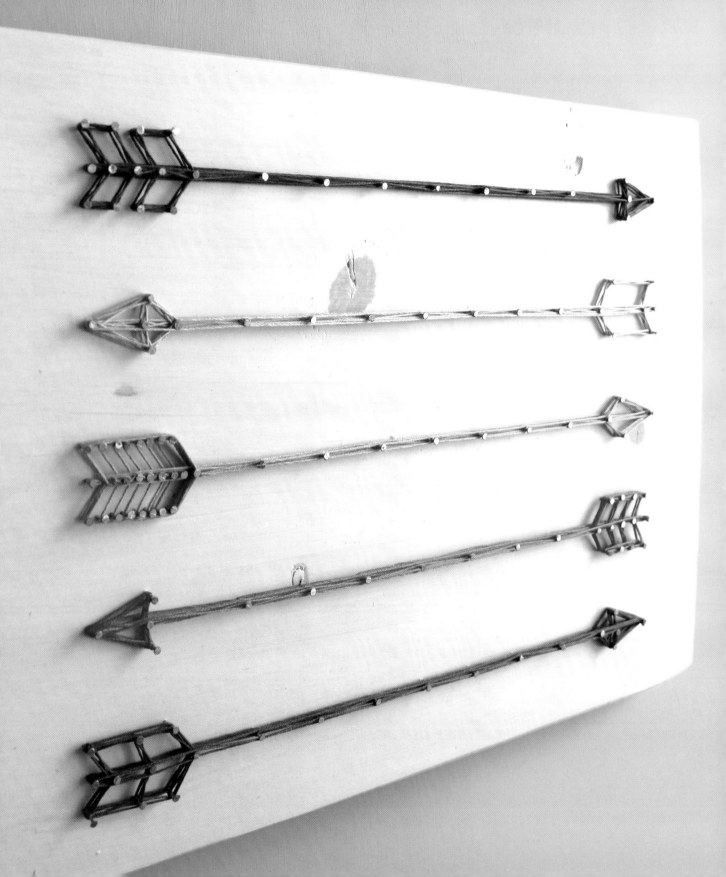

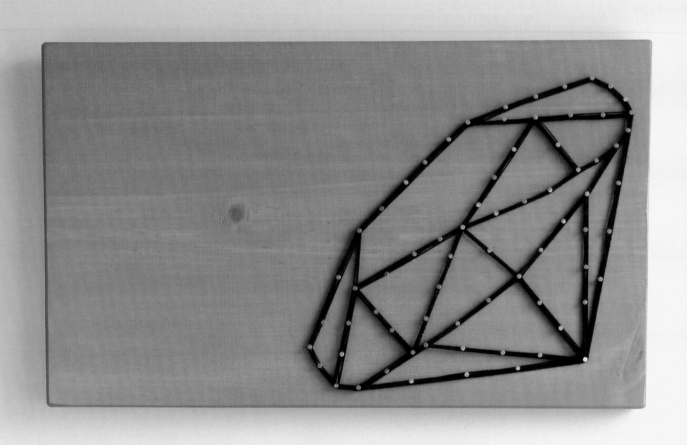

DIAMOND ON DISPLAY

DIFFICULTY: 🔨🔨

The facets on this pattern really make it pop! In this project, the string acts to draw the shape rather than fill it. There are more nails along the borders in this pattern, making it easy to fill if you prefer. If you go that route, be sure to follow up with a border in a contrasting color, to let the facets shine through. A double-wrap outline in black makes this piece stand out from across a room, and the nail heads sparkle in the light.

Materials

Pine board: 1" × 10" (2.5cm × 25.5cm), cut to 16" (40.5cm) long and stained (Shown: Minwax Water-Based Wood Stain in River Stone)

⅝" (1.6cm) silver nails

Size 10 crochet thread in 1 color (Shown: Black)

Photocopy of pattern (page 56)

Picture-hanging hardware

2 felt furniture pads

Tools: Hammer, needle-nose pliers

Basic supplies: Superglue, scissors, transparent tape

Techniques Used

Preparing a board (page 8)

Applying a nail pattern (page 9)

Stringing basics (pages 10–11)

Double-wrap technique (page 13)

Finished Size (h × w)

9.5" × 16" (24cm × 40.5cm)

DIAMOND ON DISPLAY

1 Trim your photocopied pattern and position it on your board. I prefer the lower right corner for an asymmetrical look. Tape the pattern to the board.

2 Hammer your nails through the black dots on the pattern. When you're finished, tear off the paper and remove any leftover debris.

3 Tie your string onto a nail (sealing your knot) and begin your outline. Refer to the pattern page if any areas get confusing. Connect the nails and follow up with the double-wrap technique. Don't forget to seal your knots.

4 Attach your picture-hanging hardware and felt pads to the back side. Sign and date your work and decide which room in your house needs just a little more bling.

DIAMOND ON DISPLAY PATTERN
Enlarge at 200%.

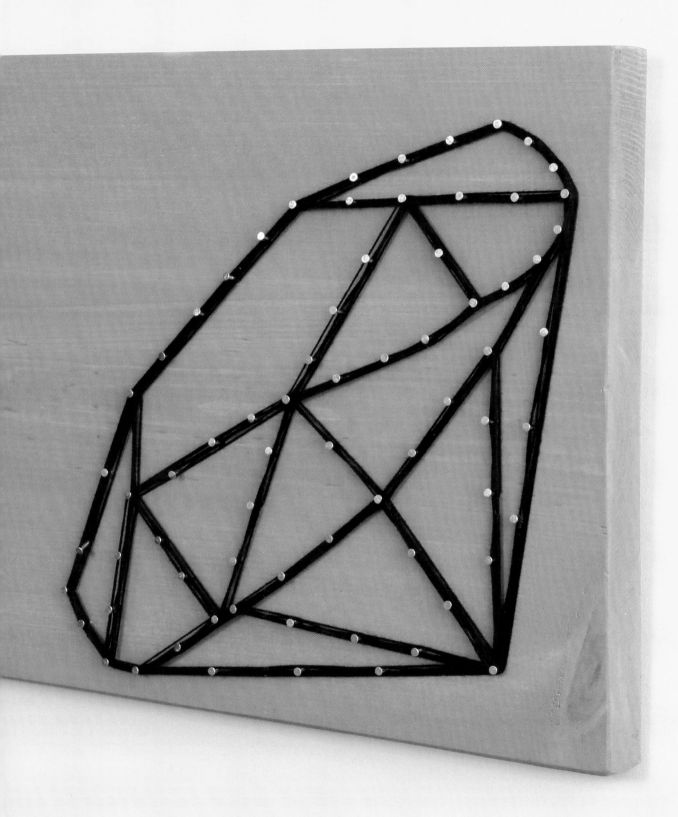

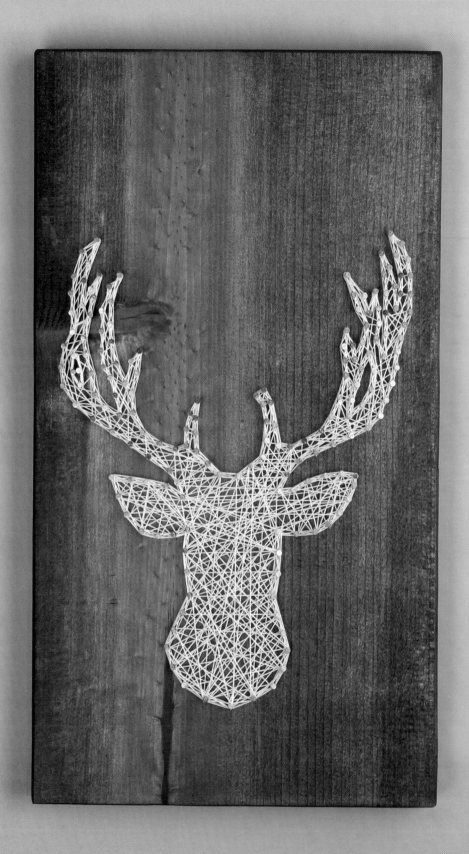

BAMBI THE BUCK

DIFFICULTY:

Did you know Bambi was a boy? I know it's commonly become a female-associated name since the feature film, but a trip down memory lane proves he was a boy. Go figure. This is a perfect rustic addition to any room. The antlers add a nice touch of the outdoors. And just think, no deer were harmed in the making of it.

Materials

Pine board: 1" × 10" (2.5cm × 25.5cm), cut to 16.5" (42cm) long and stained (Shown: Minwax Wood Finish in Early American)

⅝" (1.6cm) silver nails

Size 10 crochet thread in 1 color (Shown: White)

Photocopy of pattern (page 60)

Picture-hanging hardware

2 felt furniture pads

Tools: Hammer, needle-nose pliers

Basic supplies: Superglue, scissors, transparent tape

Techniques Used

Preparing a board (page 8)

Applying a nail pattern (page 9)

Stringing basics (pages 10–11)

Double-wrap technique (page 13)

Finished Size (h × w)

16.5" × 9.5" (42cm × 24cm)

BAMBI THE BUCK

1 This pattern takes up most of the page at full size and doesn't require trimming. You can use the edges of the page to help you center it as well. Once you're happy with its position, tape your pattern into place.

2 Start nailing through your pattern to create your design. I like to get the antlers out of the way first on this one, as it can get a little tight in there. Tear your pattern off once you've hit all the marks and remove any remaining paper.

3 Tie onto your design (sealing your knot) and begin the outline. Refer to the pattern page to help you navigate the antlers; there are a few islands, or areas that won't be filled with string. Be sure to outline these as well so they don't get buried in string. This is a surprisingly big pattern, which is why I prefer to use a spool of crochet thread with this design. Zigzag your string until you are happy with the density. This pattern looks great with a double-wrapped border. Don't forget to seal your ending knot.

4 Attach your picture-hanging hardware and felt pads to the back side. Sign and date your work and think up a name for your new friend.

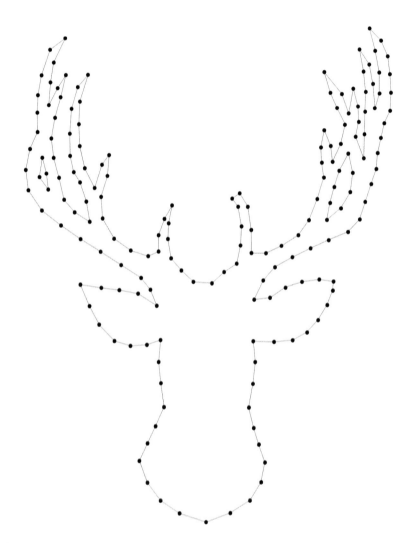

BAMBI THE BUCK PATTERN
Enlarge at 200%.

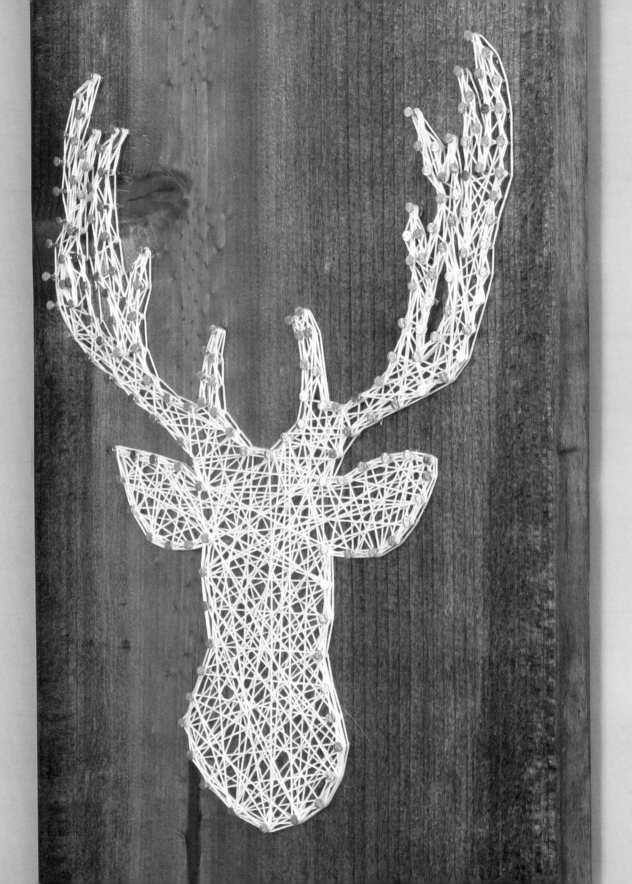

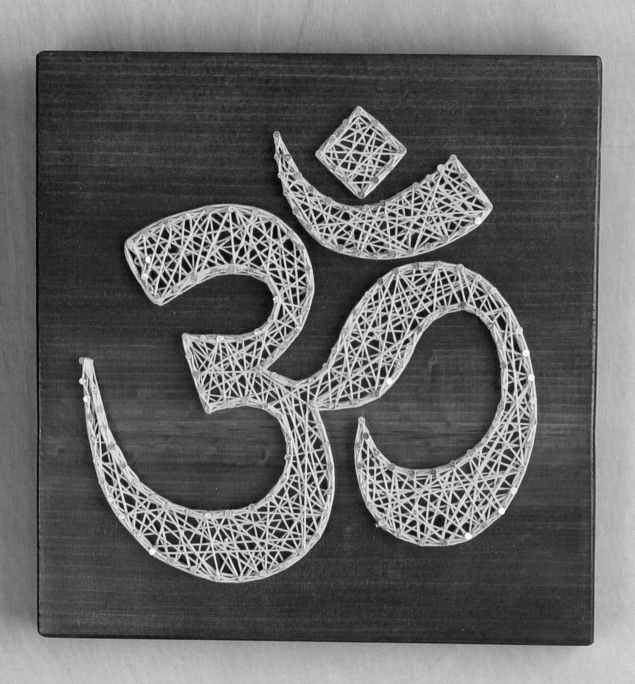

OM

DIFFICULTY: 🔨 🔨

You may be familiar with "Om" from the beginning and end of a yoga class. This ancient Sanskrit word means the "source," or universal consciousness. Also written as AUM, it represents the three-fold division of time: A is the waking state, U is the dream state, and M is the state of deep sleep. The visual symbol consists of three curves. The large bottom curve symbolizes the waking state, A. The middle represents the dream state, U, and the top curve symbolizes the state of deep sleep. This design is the perfect addition to a yoga or meditation room, or anywhere you're seeking a sense of peace.

Materials

Pine board: 1" × 10" (2.5cm × 25.5cm), cut to square and stained (Shown: Minwax Water-Based Wood Stain in Antique Red)

⅝" (1.6cm) silver nails

Embroidery floss in 1 color (Shown: DMC 742/Light Tangerine)

Photocopy of pattern (page 64)

Picture-hanging hardware

2 felt furniture pads

Tools: Hammer, needle-nose pliers

Basic supplies: Superglue, scissors, transparent tape

Techniques Used

Preparing a board (page 8)
Applying a nail pattern (page 9)
Stringing basics (pages 10–11)
Double-wrap technique (page 13)

Finished Size (h × w)

9.5" × 9.5" (24cm × 24cm)

OM

1 Position your Om pattern in the center of your square board and secure it with tape.

2 Start nailing through your pattern. I prefer to start with the smaller shapes and finish with the largest. Tear your pattern off of the nails and remove any remaining paper with your needle-nose pliers.

3 Starting with the smallest shapes, tie on (sealing your knots) and begin filling each with string. Though this pattern isn't too complex, I still find an outline helps to keep everything where it should be. Starting with the smaller shapes also helps you keep a consistent string density across the project, as you can use them as a reference. Decide ahead of time if you'd like to include the double-wrap technique along the borders, so you can add it as you go instead of repeating at the end.

4 Attach your picture-hanging hardware and felt pads to the back. Sign and date your work, then stand back and feel the good vibrations. Om…

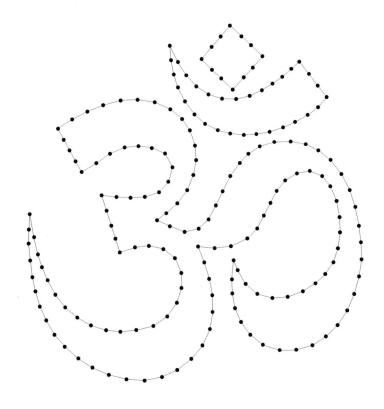

OM PATTERN
Enlarge at 200%.

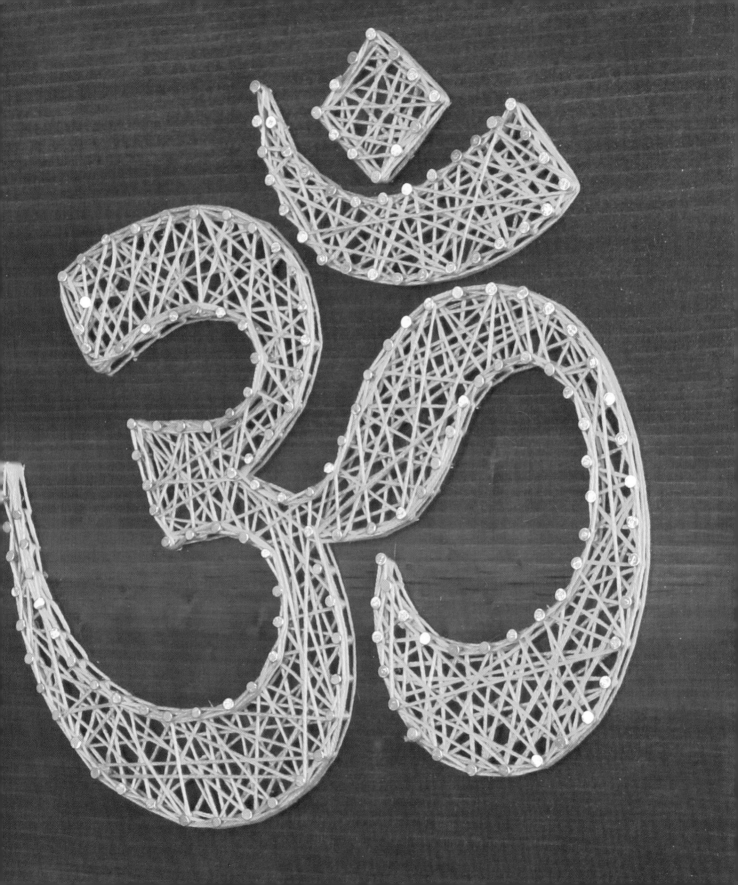

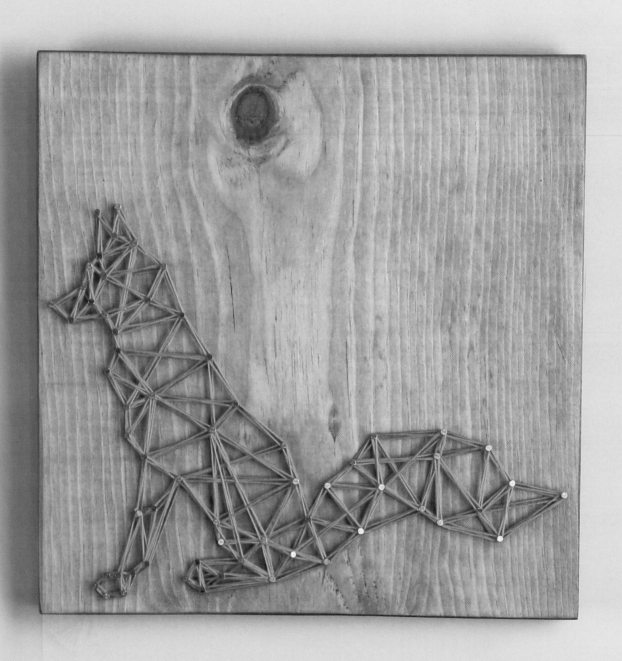

GEOMETRIC FOX

DIFFICULTY:

Another variation in string art is combining the faceted technique with the silhouette technique to create a faceted silhouette. In this project, we take the outline of a fox and give it a geometric spin for a fresh look. We will use fewer nails on the border, add nails to the inside, and draw overlapping polygons with the string. The result is almost three-dimensional and totally unique. You can do this in two ways: Follow the lines suggested in the pattern to fill the shape or go freestyle and connect the shapes to your liking.

Materials

Pine board: 1" × 12" (2.5cm × 30.5cm), cut to 11" (28cm) long and stained (Shown: Minwax Wood Finish in Weathered Oak)

¾" (1.9cm) copper weather-stripping nails

Embroidery floss in 1 color (Shown: DMC 947/Burnt Orange)

Photocopy of pattern (page 68)

Picture-hanging hardware

2 felt furniture pads

Tools: Hammer, needle-nose pliers

Basic supplies: Superglue, scissors, transparent tape

Techniques Used

Preparing a board (page 8)

Applying a nail pattern (page 9)

Stringing basics (pages 10–11)

Double-wrap technique (page 13)

Finished Size (h × w)

11.5" × 11" (29cm × 28cm)

GEOMETRIC FOX

1 Trim your pattern from the paper and position your fox on the board. Secure the pattern with tape.

2 Hammer your nails through the pattern everywhere there is a black dot. For the nails inside the shape of the fox, you can follow the marks on the pattern or do your own. When we do the string later, we will be drawing angular shapes, so you have a lot of design freedom in this step. Remove the pattern and debris.

3 Tie on (sealing your knot) and begin the outline of the fox. Now that the overall shape is clear, start filling the fox with polygon shapes. This is where you can have a lot of fun. Stretch across the shape, connecting nails to "draw" triangles, rectangles, and other angular shapes. The interior nails come in handy here. You can overlap shapes, adding more or less as you think it needs. If you don't feel comfortable in this step, refer to the pattern shown and connect the nails as I have suggested. Remember, on a pattern, the lines represent string. Be sure to seal all your knots.

4 Decide whether or not you will add the double-wrap technique, as shown in the photo.

5 Add your picture-hanging hardware and felt pads to the back side. Sign and date your work, then step back and admire the awesome angles of your geometric fox.

GEOMETRIC FOX PATTERN
Enlarge at 200%.

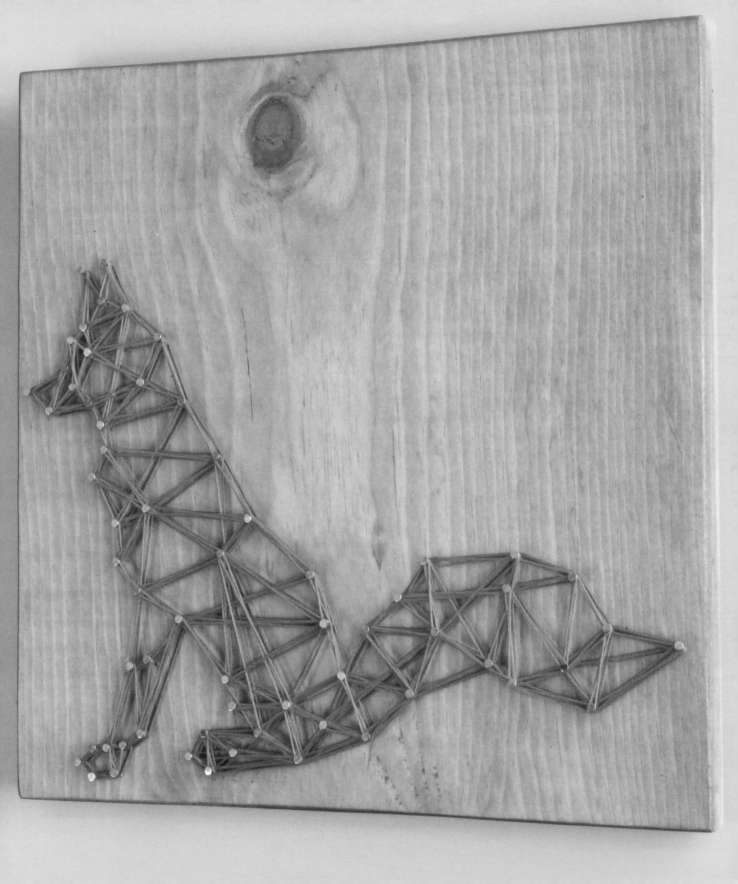

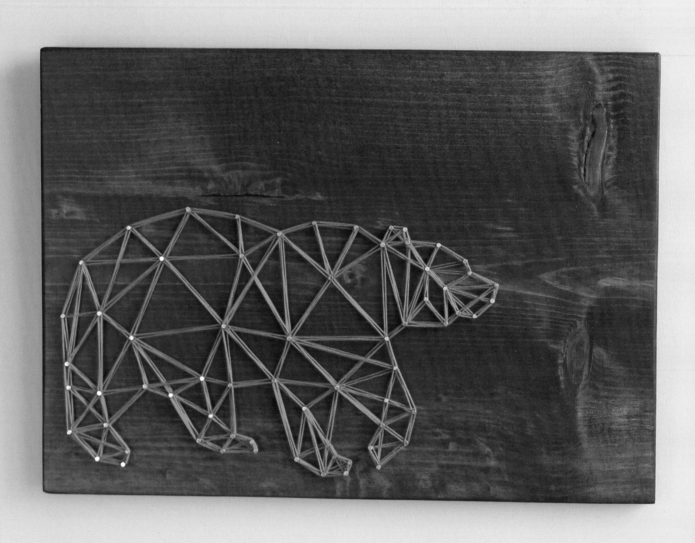

GEOMETRIC BEAR

DIFFICULTY: 🔨 🔨

I found the geometric fox to be such a fun string project that I had to jump into another. The bear, being such a large creature, is the perfect silhouette canvas for another faceted string technique. Similar to the fox project, you can follow the string examples in the pattern or go wild with your own designs. Just keep drawing polygons inside your shape and it will all come together nicely. I find this fill technique so relaxing.

Materials

Pine board: 1" × 12" (2.5cm × 30.5cm), cut to 16" (41.5cm) long and stained (Shown: Minwax Wood Finish in Red Chestnut)

⅝" (1.6cm) silver nails

Embroidery floss in 1 color (Shown: DMC 718/Plum)

Photocopy of pattern (page 72)

Picture-hanging hardware

2 felt furniture pads

Tools: Hammer, needle-nose pliers

Basic supplies: Superglue, scissors, transparent tape

Techniques Used

Preparing a board (page 8)

Applying a nail pattern (page 9)

Stringing basics (pages 10–11)

Double-wrap technique (page 13)

Finished Size (h × w)

11.5" × 16" (29cm × 41.5cm)

GEOMETRIC BEAR

1 Trim your pattern from the paper and position it on your board. I thought placing it on the bottom left looked nice with this shape. Secure your pattern with tape.

2 For the nails on the interior of the bear, you can follow the marks suggested on the pattern or do your own design. These interior nails help when you are stringing the angular shapes. The more of them you have, the more shapes you can draw with your string. Remove the pattern and debris.

3 Tie on to a nail (sealing your knot) and string the outline of the shape first. Using the same technique as the fox pattern, stretch your string across the shape. Connect to random nails and "draw" triangles, rectangles, and other polygons. Overlap as you see fit, adding more shapes as needed. If you don't feel comfortable doing this step freestyle, refer to the pattern shown for suggested string placement. Remember, on a pattern the lines represent where strings should go.

4 The bear shown was completed using the double-wrap technique, for added emphasis. Once you've finished, tie off your string and seal with superglue. Attach your picture-hanging hardware and felt pads. Sign and date your work. That's one unique bear!

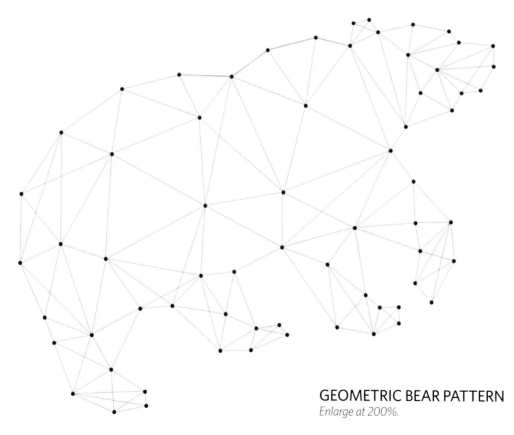

GEOMETRIC BEAR PATTERN
Enlarge at 200%.

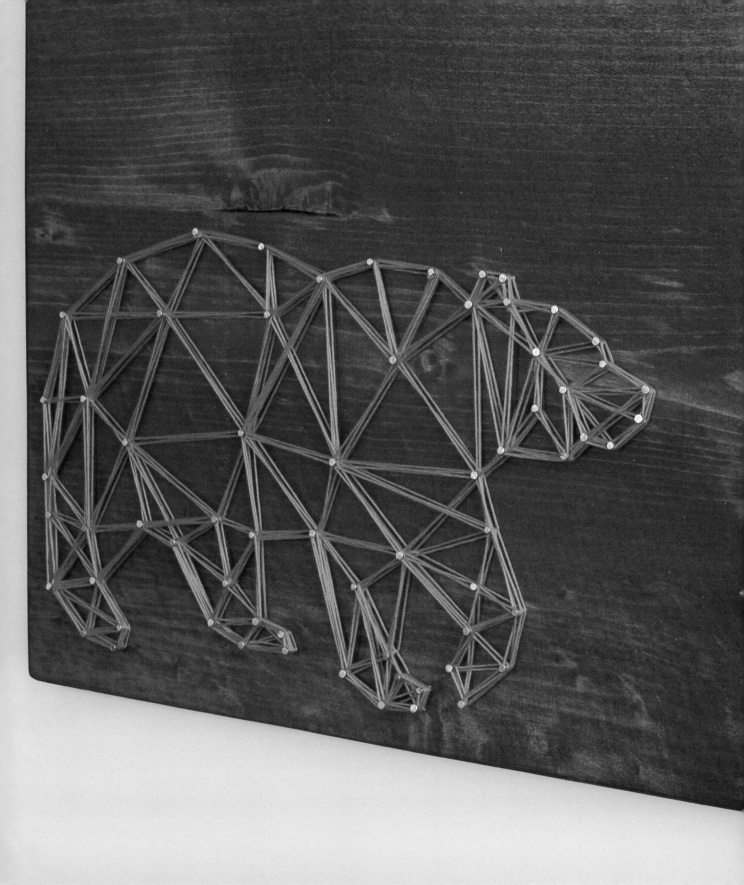

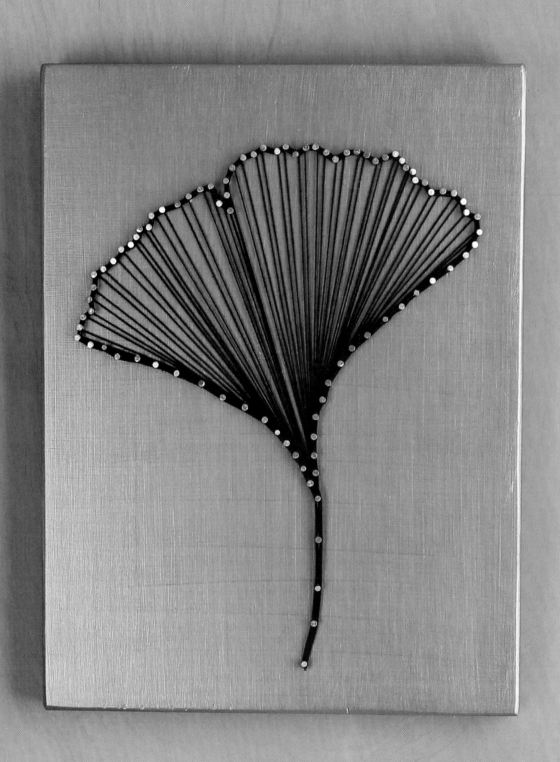

GINGKO LEAF

DIFFICULTY: 🔨 🔨

It's said that the gingko is a sacred tree of the East, a symbol of unity of opposites, a symbol of hope and love. The leaf's distinctive, aesthetically pleasing fan shape translates nicely into string art. Also, the leaf lines are perfect for string! In this project, instead of our usual fill technique, we will give our art more of a realistic appearance. You, as the artist, can of course fill the leaf however you like. Plan ahead for this one, as the layers of paint on your board will take some time to dry. This project has step photos that will help guide you in the design of the leaf fill.

Materials

Pine board: 1" × 10" (2.5cm × 25.5cm), cut to 12" (30.5cm) long and painted gold (acrylic craft paint; see step 1)

⅝" (1.6cm) silver nails

Size 10 crochet thread in black

Photocopy of pattern (page 78)

Picture-hanging hardware

2 felt furniture pads

Tools: Hammer, needle-nose pliers

Basic supplies: Superglue, scissors, transparent tape

Techniques Used

Preparing a board (page 8)

Applying a nail pattern (page 9)

Stringing basics (pages 10–11)

Double-wrap technique (page 13)

Finished Size (h × w)

12" × 9.5" (30.5cm × 24cm)

GINGKO LEAF

1 Paint your board solid gold with the craft paint. I applied five coats, alternating directions with each coat. This gives the paint a unique texture, almost like woven cloth, when the brush strokes are overlapping perpendicular to each other.

2 Trim around the pattern, position it on the board, and secure it with tape. Add nails through the pattern. If any areas feel a little tight, use your needle-nose pliers to hold the nail for you. One great thing about patterns from nature is that they are imperfect, leaving some flexibility in the design for errors. Remove the pattern and debris.

3 This project is best done with a spool of crochet thread because you want to be able to continue the design uninterrupted. Tie onto the design at the base of the leaf stem (see photo 3), trimming and sealing your knot with superglue.

4 String the nails up the stem, then stretch up to the nail at the base of the small "V" in the center of the leaf's top edge (see photo 4).

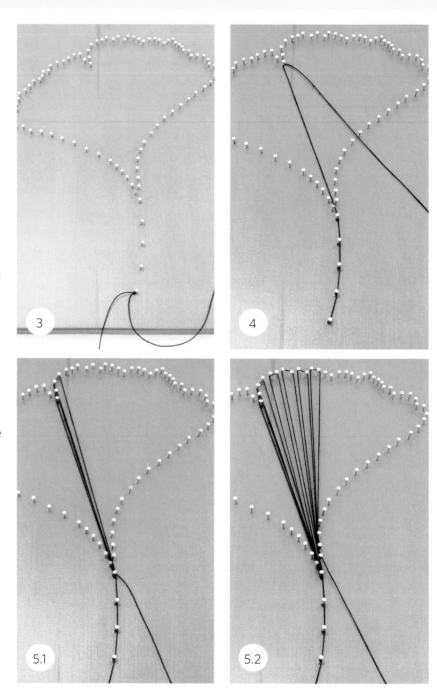

76

5 Pull your string to the next nail on the right, then stretch your string back down to the nail you started from, at the top of the leaf stem (at the fan base). Continue this back-and-forth pattern to fill the leaf (see photos 5.1–5.2). As the nails at the base of the leaf get crowded, slowly move to the nails to the right. The idea here is to fan out, giving us the distinctive gingko-leaf look.

6 Once you've completed the right side of your leaf, return to the nail at the top of the leaf stem, at the fan base (see photo 6).

7 Repeat the process from step 5, moving left instead of right to form the left side of your leaf (see photos 7.1–7.2). Remember, if the nails at the base of the fan get crowded with string, slowly move to the nails to the left.

8 Now that the leaf has been filled, you can outline your leaf with the string, using the double-wrap technique (see photo 8). Remember to secure your knots with superglue.

9 Attach the picture-hanging hardware and felt pads to the back side. Sign and date your work.

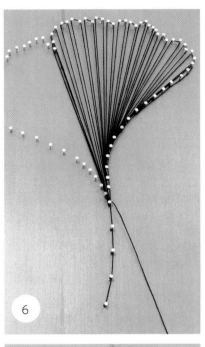

6

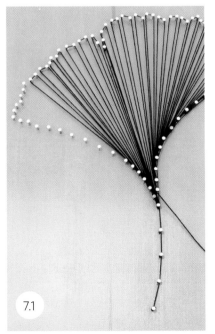

7.1

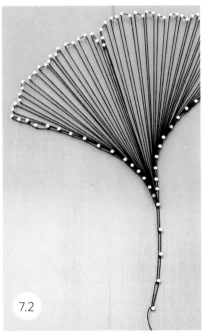

7.2

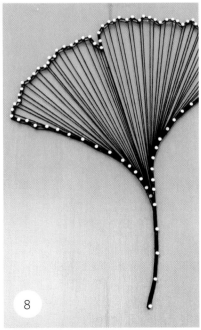

8

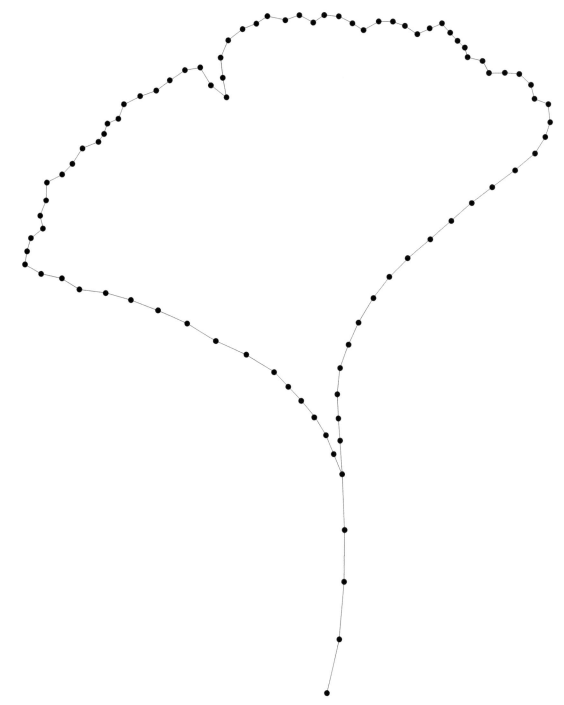

GINGKO LEAF PATTERN
Enlarge at 133%.

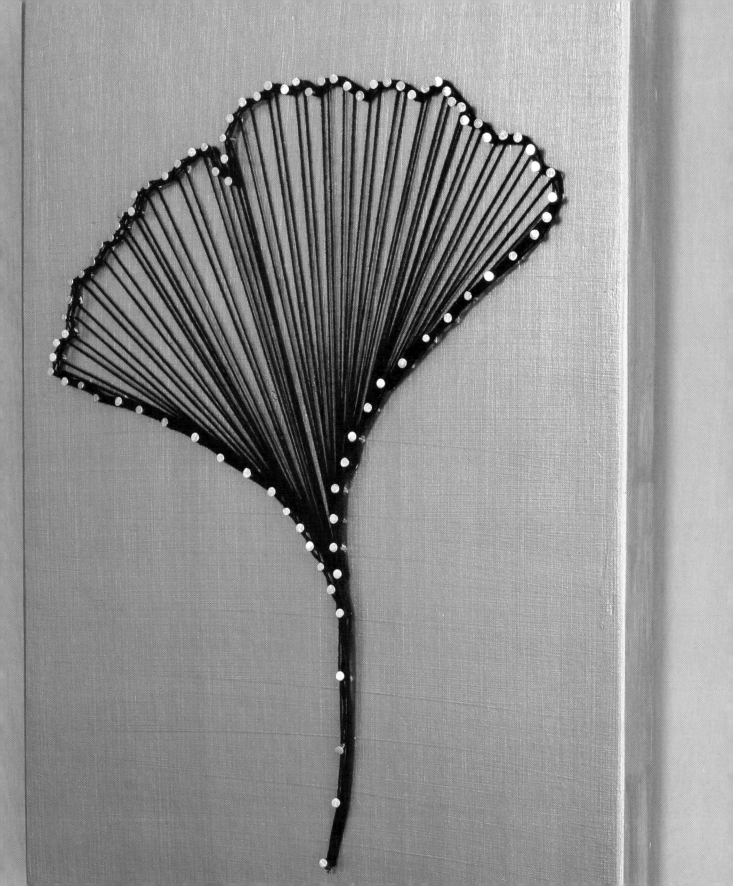

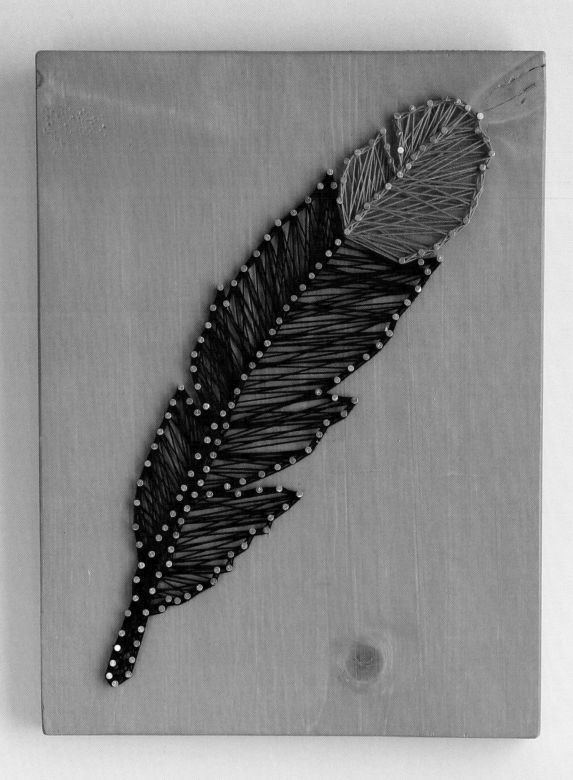

THE FEATHER

DIFFICULTY: 🔨 🔨 🔨

Similar to the gingko-leaf project, the feather
naturally works well as string art. The lines
in the vane of the feather can be realistically
portrayed with string, giving this piece a more
detailed appearance. While this pattern looks
great on its own, these would make an impact
in a group on a larger piece of wood, in different
colors and styles.

Materials

Pine board: 1" × 10" (2.5cm ×
25.5cm), cut to 12" (30.5cm) long
and stained (Shown: Minwax Water-
Based Wood Stain in River Stone)

⅝" (1.6cm) silver nails

Size 10 crochet thread in 2 colors
(Shown: Black and peacock blue)

Photocopy of pattern (page 82)

Picture-hanging hardware

2 felt furniture pads

Tools: Hammer, needle-nose pliers

Basic supplies: Superglue, scissors,
transparent tape

Techniques Used

Preparing a board (page 8)

Applying a nail pattern (page 9)

Stringing basics (pages 10–11)

Double-wrap technique (page 13)

Finished Size (h × w)

12" × 9.5" (30.5cm × 24cm)

THE FEATHER

1 Trim your pattern from the paper. Position it and tape it on your board.

2 Begin adding your nails. I recommend starting with the shaft of the feather, which is the center line, so the outer nails are not in your way after. Follow up with the border, then remove the paper and debris.

3 Start with the bottom color (I used black) and work up. This will help you form a natural "V" of the vanes that you can follow up the feather as you change colors. Tie on at the quill (sealing your knot) and start stretching lengths of string from the center line to the outside of the feather. Go back and forth from right to left to create a "V" that mimics the natural V-shape of the feather's base. Aim for a natural look, not perfection. I overlapped in a few areas for a deeper "V". Continue filling the feather with the V's, stopping where you want that color to stop. Before switching colors, go back and do the outline of this color section, as well as the shaft. Remember to seal all knots.

4 To switch colors, tie your new color (mine is peacock blue) onto an exterior nail right next to your last color. Now continue your V's, connecting the edges of the feather to the shaft.

5 When you reach the end of the feather, complete the shape by connecting the last nail on the shaft to all the remaining border nails. This gives the feather tip that unique fanlike appearance. Be sure to outline each color section the same way you did your first color.

6 Attach your picture-hanging hardware and felt pads. You're done! Be sure to sign and date your work.

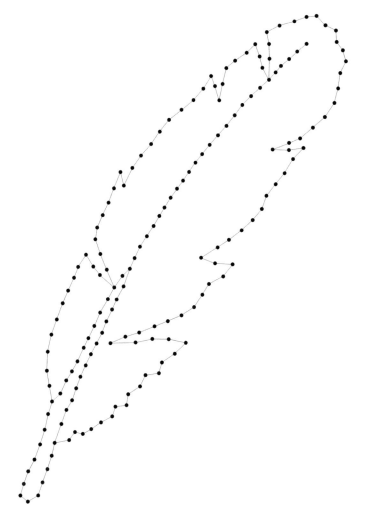

THE FEATHER PATTERN
Enlarge at 200%.

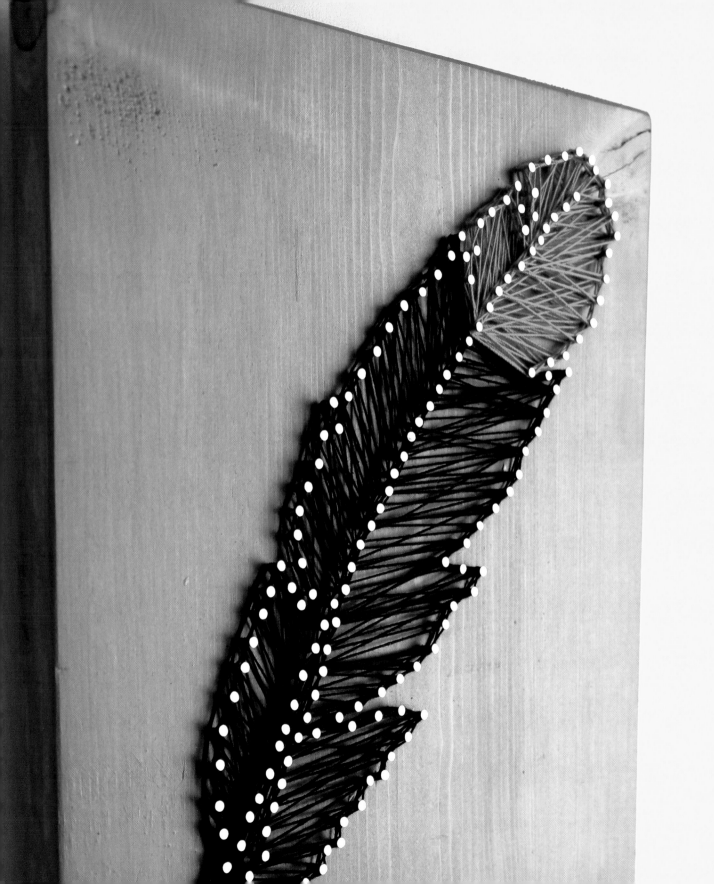

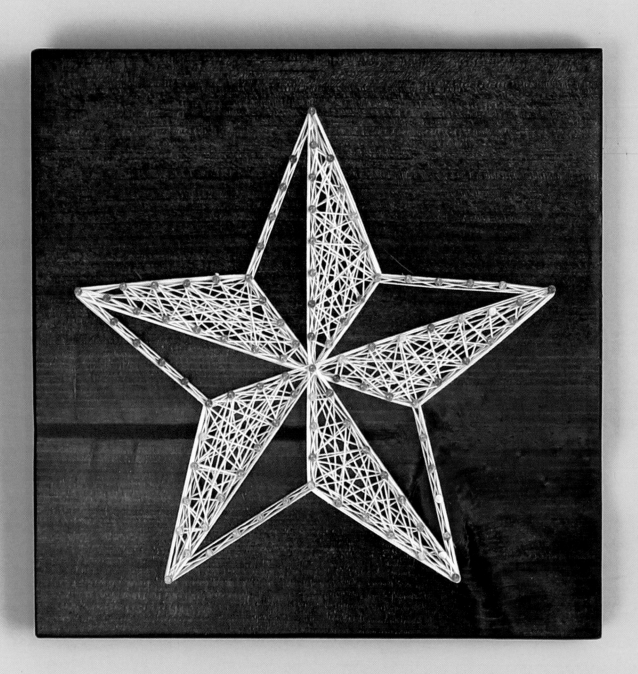

NAUTICAL STAR

DIFFICULTY: 🔨 🔨 🔨

The nautical star historically refers to Polaris, the North Star. As people took to the seas, the North Star was crucial in navigating the largely barren and landmark-less ocean. It's a totem to protection and safety and a reminder that you can always find your way home. The star's alternating color design is reminiscent of a compass rose, found on most maps and nautical charts. For this project, I'm going to alternate between string and no string, but you could easily fill the opposite with another color. If you do, you may want to outline the entire thing in a third contrasting color, such as black, to keep the shapes sharp and defined. This pattern can also be used to make a standard star—just ignore the interior nail holes.

Materials

Pine board: 1" × 10" (2.5cm × 25.5cm), cut to square and stained (Shown: Minwax Wood Finish in Dark Walnut)

¾" (1.9cm) copper weather-stripping nails

Size 10 crochet thread in 1 color (Shown: Cream)

Photocopy of pattern (page 86)

Picture-hanging hardware

2 felt furniture pads

Tools: Hammer, needle-nose pliers

Basic supplies: Superglue, scissors, ruler, transparent tape

Techniques Used

Preparing a board (page 8)

Applying a nail pattern (page 9)

Stringing basics (pages 10–11)

Double-wrap technique (page 13)

Finished Size (h × w)

9.5" × 9.5" (24cm × 24cm)

NAUTICAL STAR

1 Trim your pattern from the paper and position it on your board. If you're going to center it, a shortcut is to just make sure the center nail mark of the star is center. Then, be sure the star's top point is positioned straight up. Tape your pattern to the board.

2 Hammer your nails through the pattern. You'll want to leave the very center nail a little higher than usual. This is because all five points of the star will be utilizing that center nail, and it can get crowded with layers of string. You can always tap it back down once your project is complete. Remove the pattern and debris.

3 Tie on to one of the edges and seal your knot. Start with the outline of the star, as well as outlining the inner sections with string. Decide which side of each point will be filled with string and begin your zigzag fill technique. Either side will work, just be sure it's the same side on every star point.

4 Once all five sections have been filled, go back around and add the double-wrap technique to the border. This is highly recommended to make the shapes look sharp. Be sure to double-wrap the border of the empty sections as well. (Do this step last if you chose to fill the opposite sections with another color.) Tie off and seal your knot.

5 Attach your picture-hanging hardware and felt pads. Sign and date your work and hang your art so you'll always know your way home.

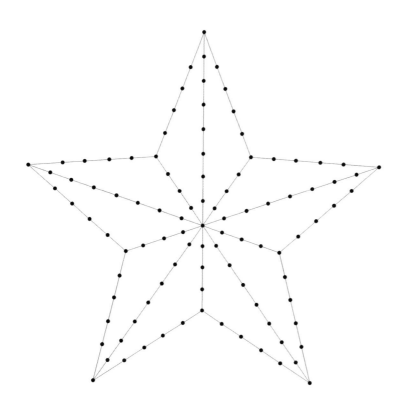

NAUTICAL STAR PATTERN
Enlarge at 200%.

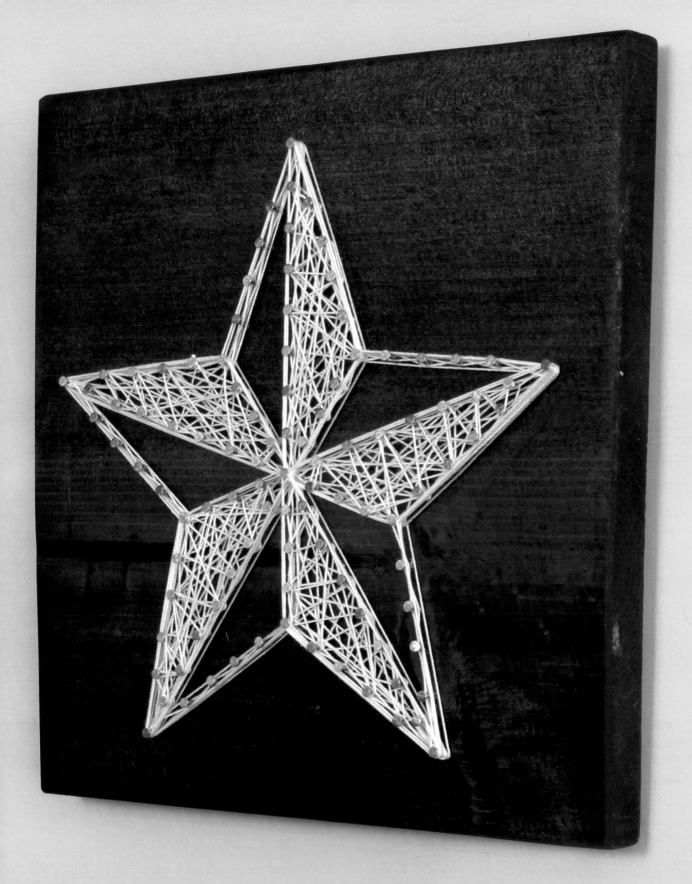

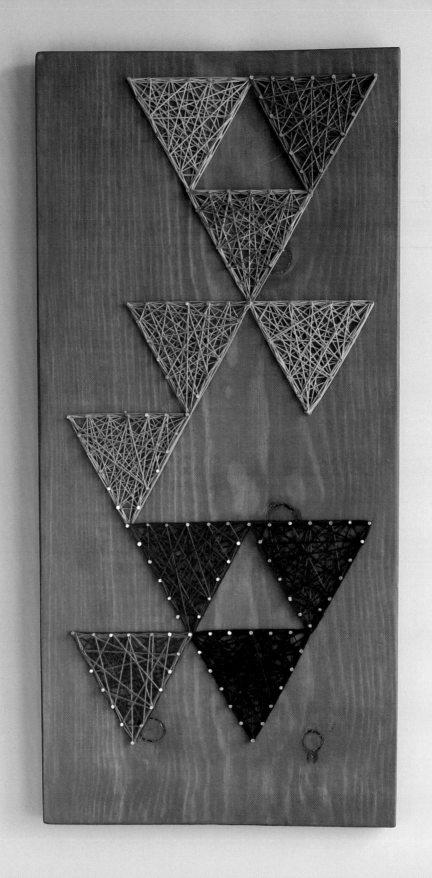

TRIANGLE TILES

DIFFICULTY: 🔨 🔨 🔨

Some of my favorite string art designs are the abstract ones, such as this grid of triangle tiles. In this project, we are going to walk through the basic steps of duplicating and expanding a pattern to fill your space. By taking multiple copies of the same pattern, you can easily trim and align portions of it to create your own unique design. You can also use this basic pattern to make larger triangles or mix and match different sizes.

Materials

Pine board: 1" × 12" (2.5cm × 30.5cm), cut to 23" (58.5cm) long and stained (Shown: Minwax Wood Finish in Classic Gray)

⅝" (1.6cm) silver nails

Embroidery floss in 8 colors (Shown: DMC 907/Light Parrot Green, 910/Dark Emerald Green, 992/Light Aquamarine, 3844/Dark Bright Turquoise, 824/Very Dark Blue, 823/Dark Navy Blue, 915/Dark Plum, 891/Dark Carnation)

2–3 photocopies of pattern (page 92)

Picture-hanging hardware

2 felt furniture pads

Tools: Hammer, needle-nose pliers

Basic supplies: Superglue, scissors, thumbtacks, transparent tape

Techniques Used

Preparing a board (page 8)

Applying a nail pattern (page 9)

Stringing basics (pages 10–11)

Double-wrap technique (page 13)

Finished Size (h × w)

23" × 11.5" (58.5cm × 29cm)

TRIANGLE TILES

Note: These steps describe and show the general method of connecting triangle tiles in whatever pattern you choose. Shown on page 93 is just one of many possible designs.

1 Tape one photocopy of the pattern to your board where you'd like to start. I started in the top right, with my board vertical (see photo 1).

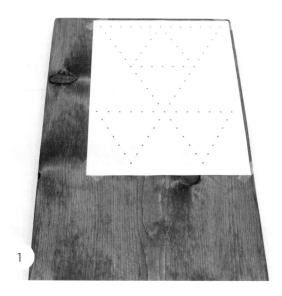

2 Use thumbtacks through the nail marks to align the top of the second pattern with the bottom of the first. Here's how: On the second copy, put a thumbtack through a top triangle's corner nail hole. We use the corner nail because it is shared with the adjacent triangles, making it easier to align. Now align that thumbtack with the bottom tip of a triangle on the first taped pattern (see photo 2). Don't worry about putting a hole in the wood; you'll be nailing there later anyway.

3 Repeat this process with the opposite corner, successfully lining up your second pattern with the first (see photo 3). Secure the pattern to your board with tape and remove the thumbtacks.

4 If you want to customize and add a few more triangles, trim them from a third copy and use the same thumbtack alignment technique (see photos 4.1–4.3).

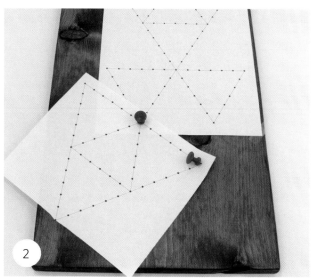

5 From here on out, it's business as usual. You may want to mark which triangles you're going to be using, so you don't lose track while adding the nails. One suggestion I have is to not hammer the triangle corner nails too deep. If it's a corner that is shared with another triangle, it will get pretty thick with string layers. You can always tap the nail in further once the project is complete. Once all the nails are in, remove the paper and debris.

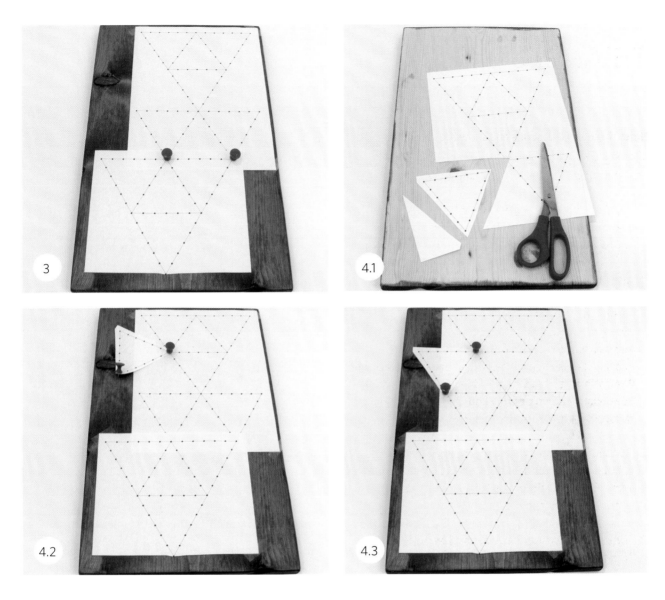

6 I chose to string in rainbow order (from greens to blues to purple, in my example), so I could blend some of the strings from triangle to triangle. Remember to seal the knots with superglue as you go. Have fun with it! This is an abstract design, so go with the flow. Aside from blending, I also went with a double-wrap border.

7 Attach your picture-hanging hardware and felt pads to the back. Sign and date your work, and you've successfully expanded a string art pattern.

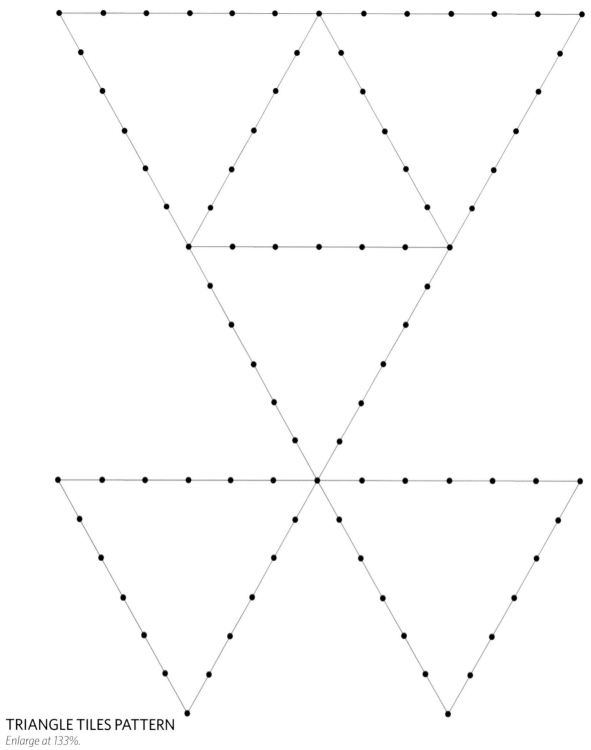

TRIANGLE TILES PATTERN

Enlarge at 133%.

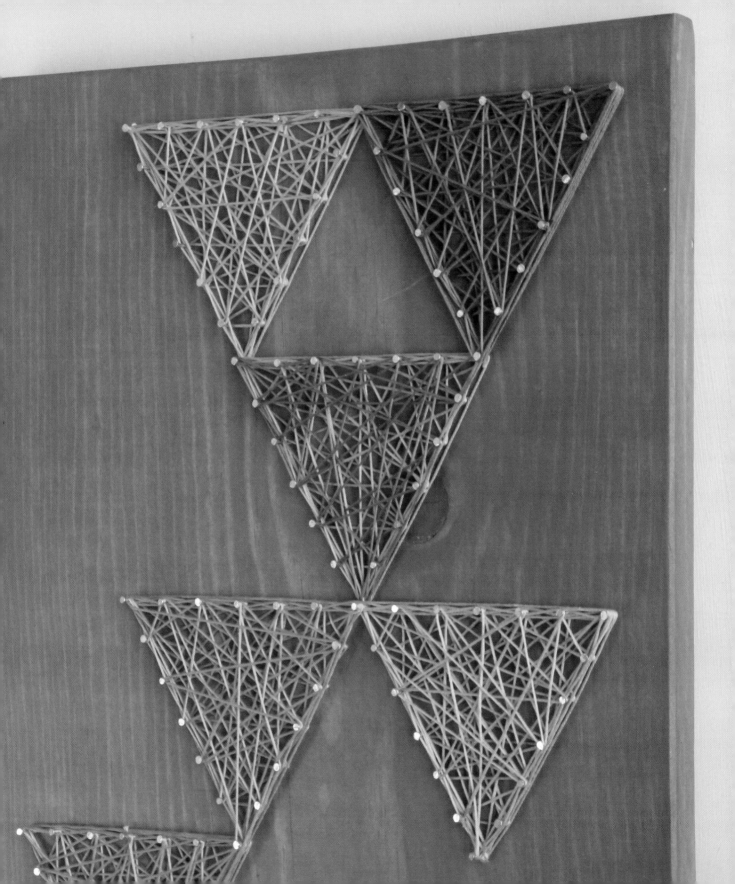

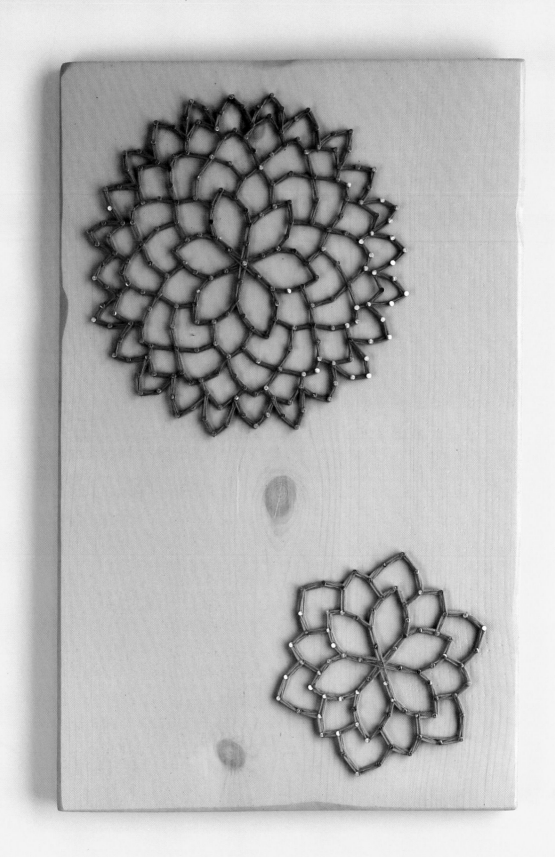

CHRYSANTHEMUM

DIFFICULTY: 🔨 🔨 🔨

Chrysanthemums symbolize fidelity, optimism, joy, and long life. Who wouldn't want that symbol in their home? I love the detail work on this project. It's done solely using the double-wrap technique and makes for a very impressive string art piece that will really show off your skills. When you remove the pattern, the amount of nails will seem daunting, but it starts to make sense once you begin the outline. This pattern can be trimmed to make many different-sized flowers, as we'll do here for the smaller chrysanthemum.

Materials

Pine board: 1" × 12" (2.5cm × 30.5cm), cut to 17" (43cm) long and stained (Shown: Minwax Water-Based Wood Finish in Driftwood)

⅝" (1.6cm) silver nails

Size 10 crochet thread in 1 color (Shown: Peacock blue)

Embroidery floss in 1 color (Shown: DMC 3340/Medium Apricot)

2 photocopies of pattern (page 96)

Picture-hanging hardware

2 felt furniture pads

Tools: Hammer, needle-nose pliers

Basic supplies: Superglue, scissors, transparent tape

Techniques Used

Preparing a board (page 8)

Applying a nail pattern (page 9)

Stringing basics (pages 10–11)

Double-wrap technique (page 13)

Finished Size (h × w)

17" × 11.5" (43cm × 29cm)

CHRYSANTHEMUM

1 Trim your photocopied pattern and position it on your board. For the smaller flower in this project, I simply trimmed a second copy down to three petal layers. Secure your patterns with transparent tape.

2 Starting on one side of the pattern, work your way across, hammering nails into all of the black dots. Get comfortable, there are a lot! You'll most likely need the help of your needle-nose pliers to remove this pattern, as this amount of nails makes it pretty tight on the board. Remember, it's okay if you can't remove every last piece of paper from around the nails—the string will hide any small bits.

3 Before you can really get started on the double-wrap of this pattern you need to outline the flower petals, to be able to see the shape. I suggest starting from the center and "drawing" the petals as you move outward. Once you have the center six petals outlined, it starts to make a little more sense. Refer to the pattern page to help you navigate this sea of nails. I chose to use a spool of crochet thread for the larger flower so I wouldn't have to add many knots to such an intricate pattern. Be sure to seal that center starting knot; a lot of tension will be on it.

4 Once you have outlined all the petals, it's only a matter of coming back around and applying the double-wrap technique to your outlines. Repeat this process for the smaller flower. Don't forget to seal any knots made.

5 Attach your picture-hanging hardware and felt pads to the back. Sign and date your work. Enjoy this one: it was no small feat!

CHRYSANTHEMUM PATTERN
Enlarge at 200%.

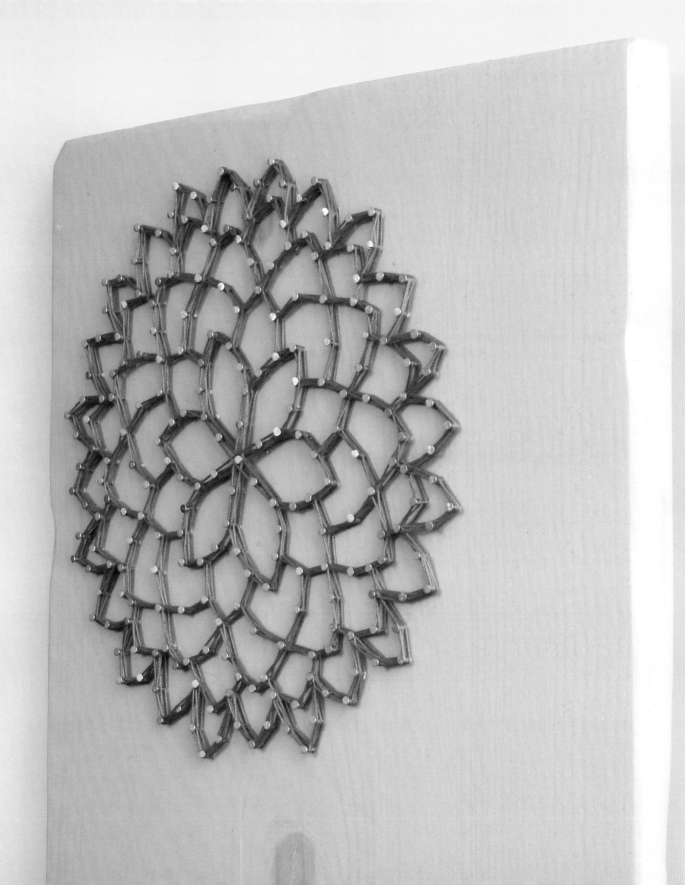

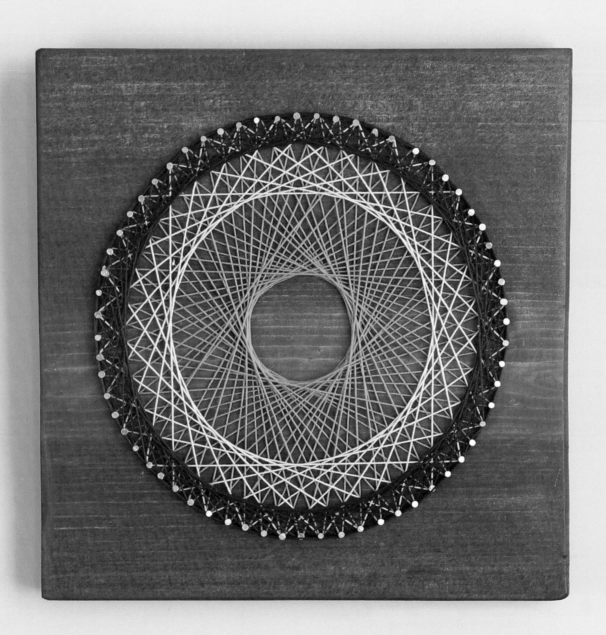

RETRO SPIROGRAPH

DIFFICULTY: 🔨 🔨 🔨

Did you ever play with a Hasbro Spirograph growing up? It was a mathematical drawing toy that used a pen and a set of cogged circles to create mesmerizing designs. I had one, and this retro string art design totally reminds me of it. One of my favorite color schemes is mono-chromatic, or choosing different tones of the same color. I use spools of crochet thread for this project, so I don't have to spoil the fun with stopping now and then for knots.

Materials

Pine board: 1" × 10" (2.5cm × 25.5cm), cut to square and stained (Shown: Minwax Wood Finish in Red Chestnut)

⅝" (1.6cm) silver nails

Size 10 crochet thread in 3 colors (Shown: Peacock blue, parakeet blue, navy blue)

Photocopy of pattern (page 100)

Picture-hanging hardware

2 felt furniture pads

Tools: Hammer, needle-nose pliers

Basic supplies: Superglue, scissors, transparent tape

Techniques Used

Preparing a board (page 8)

Applying a nail pattern (page 9)

Stringing basics (pages 10–11)

Finished Size (h × w)

9.5" × 9.5" (24cm × 24cm)

RETRO SPIROGRAPH

1 Trim your photocopied pattern, center it on your board, and tape it down.

2 Hammer the nails through your pattern to form the circle. Wait to correct any crooked nails until the circle is finished. Step back and check that the pattern looks circular to the naked eye. You can gently tap nails from the side if they are noticeably offset. Remove the pattern and debris.

3 Tie your crochet string onto any nail and seal your knot. Since we are layering three colors in this project, start with the color you want on the bottom layer.

4 Stretch your string across the circle to a nail on the other side. The nail you pick will determine about how big the center opening formed will be once your project is finished. You'll want a small opening so that you have room for the next two layers of string. Once you've chosen the nail to string to, count how many nails away it is from your starting nail. For my example, the nail I chose is the twenty-seventh one away from my starting nail, moving along the left side

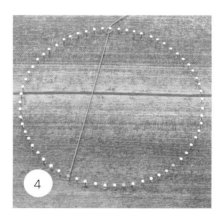

4

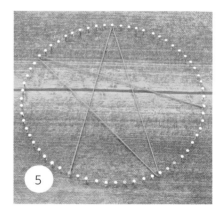

5

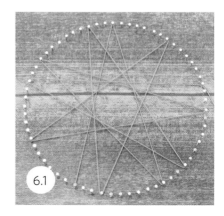

6.1

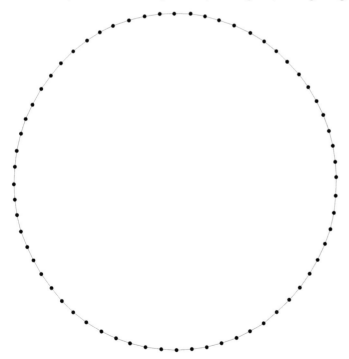

RETRO SPIROGRAPH (BASIC CIRCLE) PATTERN
Enlarge at 200%.

100

of the circle (see photo 4). Write down this number!

5 Continuing in the same direction around the circle, count another twenty-seven nails (or whatever your number is) and wrap your string. Then repeat (see photo 5).

6 Continue counting the same number, in the same direction, and wrapping (see photos 6.1–6.2). With some numbers, a pattern will emerge that makes it obvious which nail is next. If you lucked out with one of those, it will save you some counting! Your pattern is complete when the counting brings you back to your starting nail. Tie and trim your string, sealing the knot.

7 Let's add another color layer. Tie your crochet thread onto any nail. It's best to use a different nail than you started with on the last layer, to avoid a large buildup of superglue and knots on one nail. Then, similar to step 4, stretch your new color of string across the circle. You'll want the diameter of this opening to be larger than the last, so it should be a lower number. For my example, I chose the eighteenth nail away, up the left side of the circle; then I continued by counting over another eighteen (see photo 7).

8 Exactly as in previous steps, continue counting the same number in the same direction around the circle (see photos 8.1–8.3). Your layer is complete once the counting brings you back to your starting nail. Tie, trim, and seal your knot.

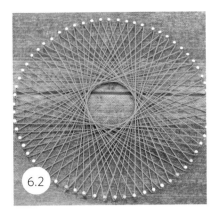
6.2

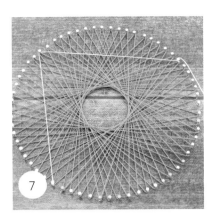
7

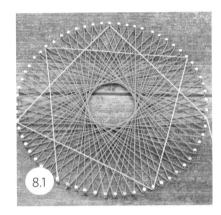
8.1

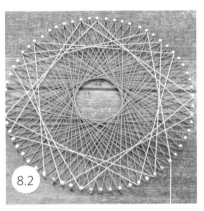
8.2

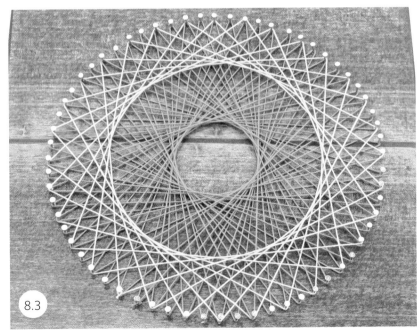
8.3

Note: You'll notice on my second layer that not all the nails were included. This is fine; each number you will use to count will have a different pattern outcome. This just happens to be what counting eighteen looks like. As long as your counting was correct and you end up back on your starting nail, you know you kept to your pattern.

9 Time to add the final layer. Adding a thinner contrasting layer really frames the piece. Tie your third layer of string to any nail on the circle (see photo 9).

10 Stretch your string across to determine the diameter of your opening. Again, it should be your widest opening yet, and therefore your smallest counting number. For my example, I'm using the eleventh nail up the left side. Continue counting the same number of nails in the same direction and wrapping these nails (see photo 10).

11 Here you can see I lucked out, and one lap around the circle brought my string one nail away from my original (see photo 11). This means rather than counting, I can string to the nail one away from each nail around the circle, and so on (though I do count now and then to double-check).

12 Your layer is complete when you reach your starting nail. To add an optional outline, you can do a few quick laps on the outer circle in string to build up the border. There's no need to wrap on each nail for this step; the tension holds it in place. Tie, trim, and seal your knot.

13 Attach your picture-hanging hardware and felt pads to the back. Sign and date your work. Congratulations on making such a far-out piece of retro art!

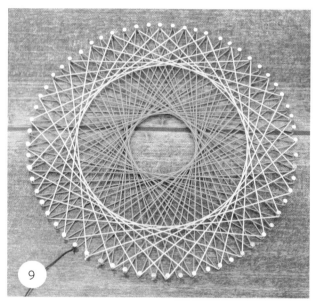

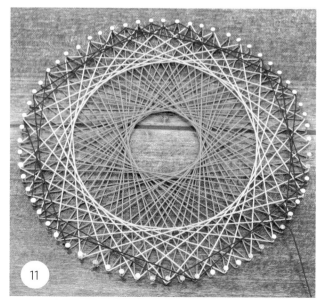

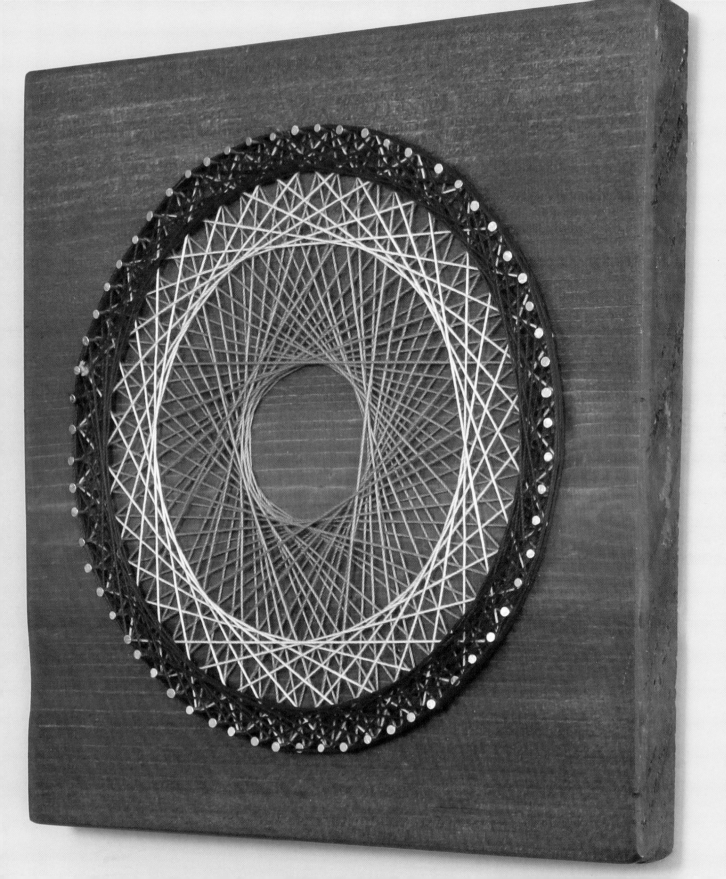

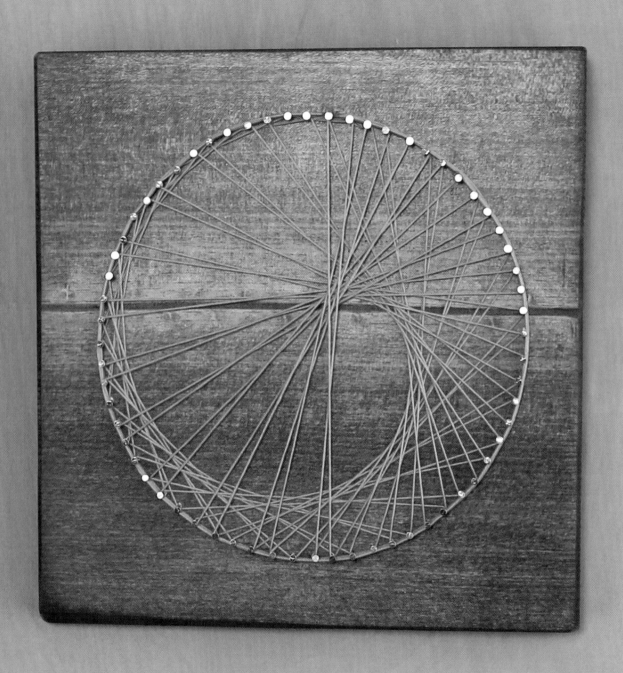

SEA SNAIL SPIRAL

DIFFICULTY: 🔨 🔨 🔨

The pattern created by this string art reminds me of a snail shell. The spiral formed is a special one, called a logarithmic spiral. To make it easier to understand, I'll demonstrate the steps through pictures. Once you get the rhythm down, this piece is really fun to make.

Materials

Pine board: 1" × 10" (2.5cm × 25.5cm), cut to square and stained (Shown: Minwax Water-Based Wood Finish in Dark Walnut)

⅝" (1.6cm) silver nails

Embroidery floss in 1 color (Shown: DMC 3853/Dark Autumn Gold)

Photocopy of pattern (page 107)

Picture-hanging hardware

2 felt furniture pads

Tools: Hammer, needle-nose pliers

Basic supplies: Superglue, scissors, transparent tape

Techniques Used

Preparing a board (page 8)

Applying a nail pattern (page 9)

Stringing basics (pages 10–11)

Finished Size (h × w)

9.5" × 9.5" (24cm × 24cm)

SEA SNAIL SPIRAL

1 Position and tape down your pattern on the board.

2 Hammer the nails through your pattern to form the circle. Wait to correct any crooked nails until the circle is finished. Step back and check that the pattern looks circular. Gently tap nails from the side if they are noticeably offset. Remove the pattern and debris.

3 Tie your crochet string onto any nail. Trim the string and seal your knot with glue. This will be Nail 1.

4 Move one nail to the right and wrap your string onto the nail (see photo 4). This will be Nail 2.

5 Skip a nail to the right and wrap your string on Nail 4 (see photo 5).

6 Return back to Nail 2, wrap with string, then pass Nail 3 (one to the right) and through the inside of the circle to the next available nail on the right (Nail 5) and wrap that nail (see photos 6.1–6.2).

7 Now that you're on Nail 5, skip a nail to Nail 7 and return across the inside of the circle to Nail 4 (see photos 7.1–7.2).

8 You should be on Nail 4; now move one to the right and wrap around Nail 5 (see photo 8).

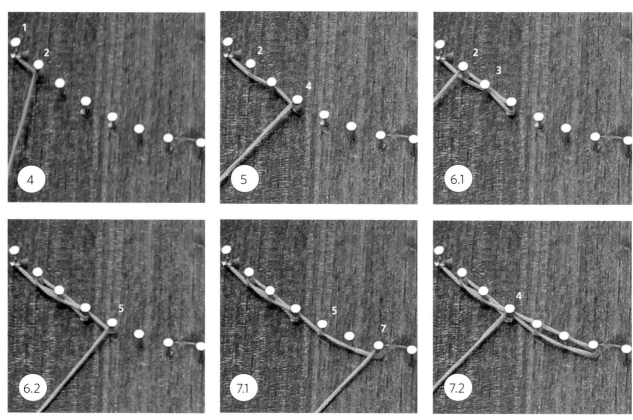

9 Similar to step 6, stretch your string across the inside of the circle from Nail 5 to the next available nail (Nail 8) and wrap that nail (see photo 9).

10 From Nail 8, you'll skip to Nail 10, returning across to the next nail in the sequence, Nail 6. You can see the pattern forming in photo 10. On one side, we are working nail by nail, in order—returning to Nail 6 and moving only one to Nail 7, returning to Nail 8 and moving only one to Nail 9. While on the other side, we are stretching to the next available nail and skipping one before the return.

RETRO SEA SNAIL (BASIC CIRCLE) PATTERN
Enlarge at 200%.

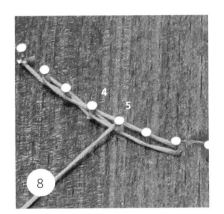

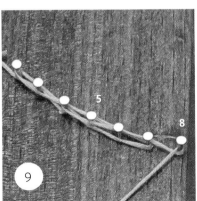

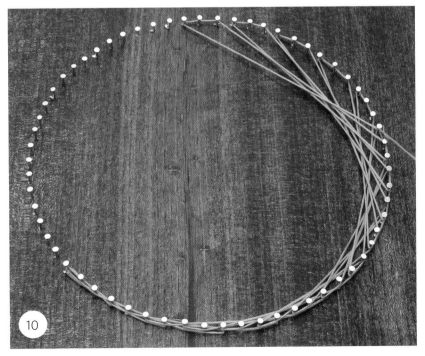

11 Continue around the circle in this pattern for as long as you'd like (see photos 11.1–11.2). I chose to stop just before the spiral closed. Once you've decided to stop, wrap a few layers of border on the outside of the circle (see photo 11.2). Tie, trim, and seal your knot.

12 Attach your picture-hanging hardware and felt pads to the back. Enjoy!

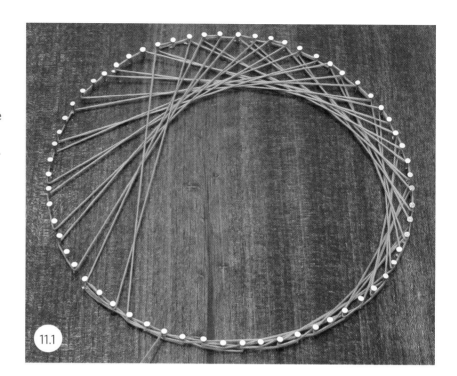

11.1

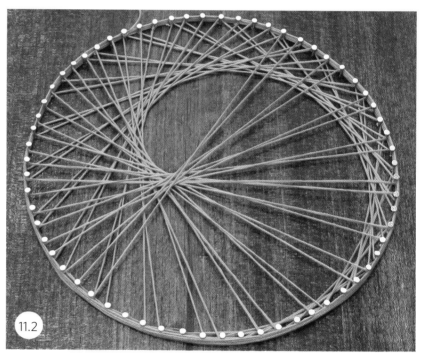

11.2

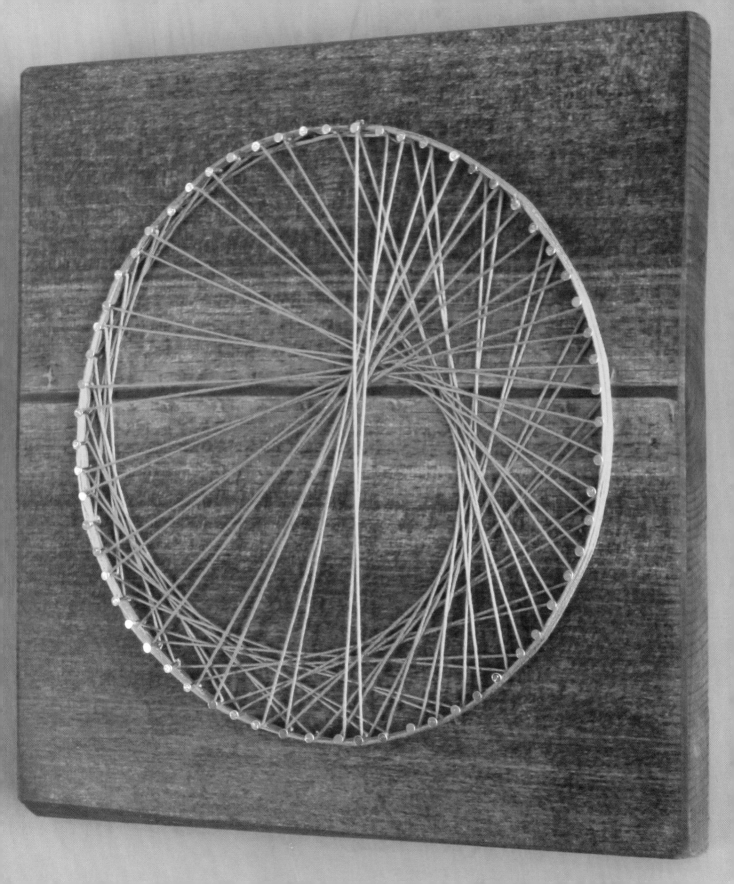

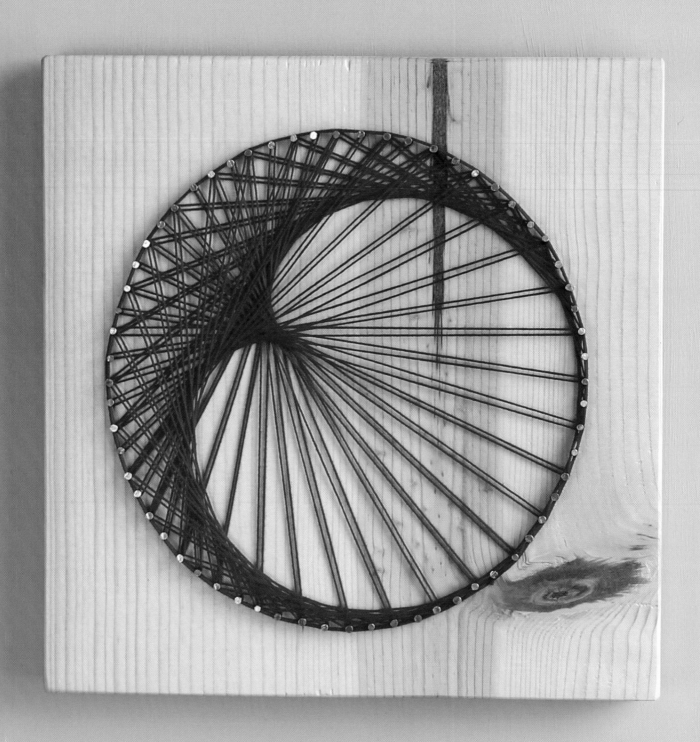

CRESCENT MOON

DIFFICULTY:

The crescent moon is a classic string art design from the 1970s and actually what inspired me to get into string art. I fell in love with the design when I saw it large scale, and I knew I had to try it. This was one of my first string art projects, and it's still a favorite. We use the same basic circle pattern for this. There are two variations: one is to nail every other hole in the pattern, 32 nails instead of 64. Following the same technique will give you a less dense result. The other, more detailed version is shown here.

Materials

Pine board: 1" × 10" (2.5cm × 25.5cm), cut to square and sealed (Shown: Minwax Polycrylic)

⅝" (1.6cm) silver nails

Size 10 crochet thread in 1 color (Shown: Red)

Photocopy of pattern (page 113)

Picture-hanging hardware

2 felt furniture pads

Tools: Hammer, needle-nose pliers

Basic supplies: Superglue, scissors, transparent tape

Techniques Used

Preparing a board (page 8)

Applying a nail pattern (page 9)

Stringing basics (pages 10–11)

Finished Size (h × w)

9.5" × 9.5" (24cm × 24cm)

CRESCENT MOON

1 Trim your pattern and position it on your board. Secure the pattern with tape.

2 Hammer the nails through your pattern to form the circle. Wait to correct any crooked nails until the circle is finished. Step back and check that the pattern looks circular to the naked eye. You can gently tap nails from the side if they are noticeably offset. Remove the pattern and debris.

3 Tie your thread onto any nail. Trim and seal your knot. This will be Nail 1.

4 Wrap your string to the next nail (Nail 2) and return to Nail 1 (see photo 4).

5 Starting from Nail 1, skip a nail and stretch to Nail 3, then return to Nail 1 (see photo 5).

6 Now that you are back on Nail 1, move one to the right to Nail 2 (see photo 6).

7 Now starting from Nail 2, stretch your string across the interior of the pattern, skip the next available nail on the

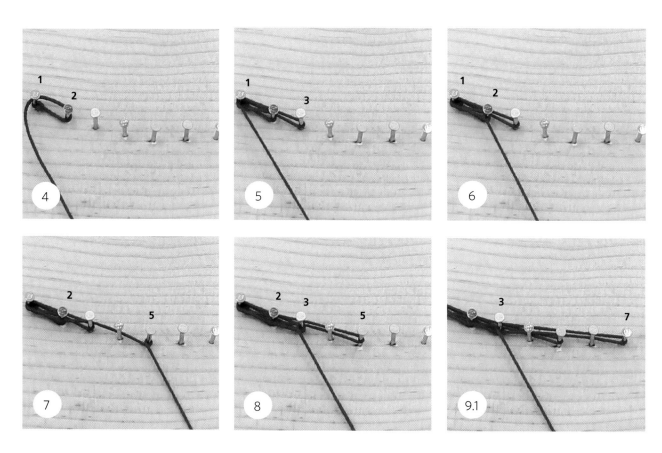

right, and wrap the following nail, which would be Nail 5 (see photo 7).

8 Return to your starting nail, Nail 2, from Nail 5. Move one to the right, to Nail 3 (see photo 8).

9 Repeating the pattern, you'll now stretch from the starting point of Nail 3 and skip the next available nail on the border. You should have stretched your string to Nail 7. Return the string from Nail 7 to its starting point of Nail 3 and move one to the right to Nail 4 (see photos 9.1–9.2).

10 Continue this pattern around the circle, until you are back at your first nail, and the crescent is complete (see photos 10.1–10.4). You can see that on one side we are working nail by nail, in order, stretching across to every other nail. The moon will naturally form when you continue to repeat this sequence, starting from a nail, stretching across to skip a nail, returning to the starting nail, and moving one to the right. You'll

RETRO CRESCENT MOON (BASIC CIRCLE) PATTERN
Enlarge at 200%.

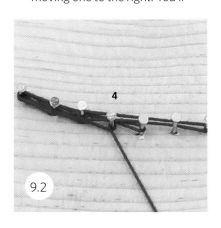

9.2

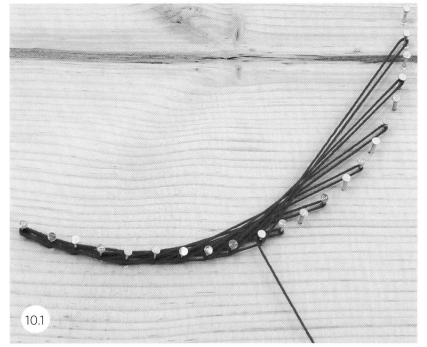

10.1

want to be sure you are wrapping in the same direction on the nails, so your string forms what looks like loops rather than X's.

11 Add a border by wrapping your crochet thread around the outside of the circle two or three times (see photo 11). There's no need to wrap each nail of the border, as the tension will hold it in place. Tie, trim, and seal your knot.

12 Attach your picture-hanging hardware and felt pads to the back. Sign and date your work, and enjoy this blast from the past.

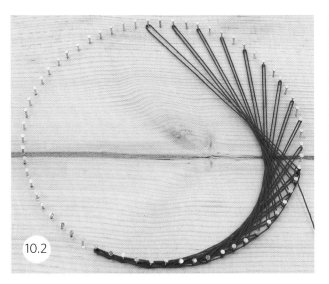

10.2

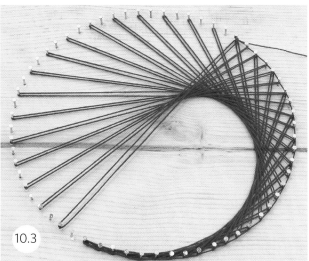

10.3

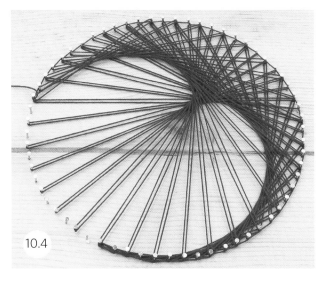

10.4

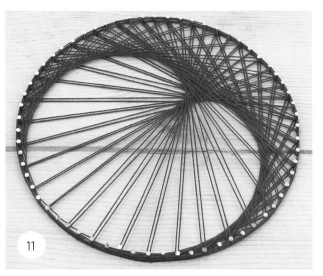

11

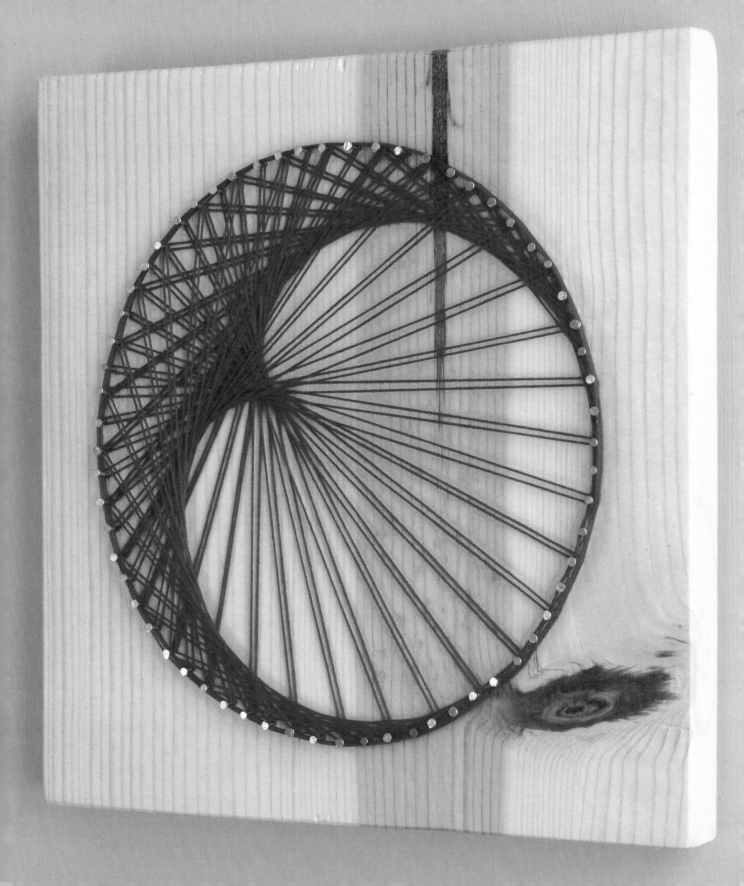

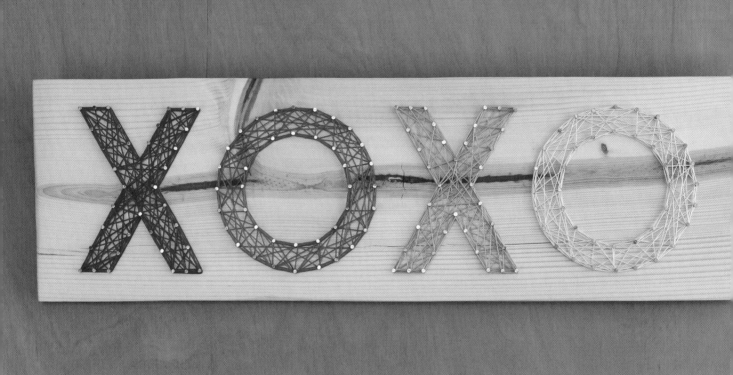

HUGS 'N KISSES

DIFFICULTY:

Hugs and kisses, X's and O's! In this project, we will fill the letters with random string patterns. This technique gives the letters depth and dimension, and the nail heads provide a little sparkle. Here, you can see we did a gradual blend from one color hue to another for an ombré effect, which looks great in many colors. Take your time measuring and centering the letters to get them right. Measure twice, nail once!

Materials

Pine board: 1" × 8" (2.5cm × 20.5cm), cut to 24" (61cm) long and sealed (Shown: Minwax Polycrylic)

⅝" (1.6cm) silver nails

Embroidery floss in 4 colors (Shown: DMC 600/Very Dark Cranberry, 335/Rose, 894/Very Light Carnation, 963/Ultra Very Light Dusty Rose)

2 photocopies of pattern (page 118)

2 sets of picture-hanging hardware

2 felt furniture pads

Tools: Hammer, needle-nose pliers

Basic supplies: Superglue, scissors, ruler, transparent tape

Techniques Used

Preparing a board (page 8)

Applying a nail pattern (page 9)

Stringing basics (pages 10–11)

Double-wrap technique (page 13)

Finished Size (h × w)

7.5" × 24" (19cm × 61cm)

HUGS 'N KISSES

1 Trim your pattern and position it on your board. Before you start, align and tape your two copies of the pattern together. Then, use your ruler to center it. I like to move the pattern edge (left side) entirely to the left of my board and measure the remaining distance from the pattern edge (right side) to the right edge of my board. Divide that number in half for the distance that should be on each side of your pattern. Remember to center the letters of your pattern, not the actual paper itself, since your letters may not be centered on your paper. Secure the pattern with tape in several places.

2 Hammer the nails directly through the pattern, on every black dot. Since I hammer with my right hand and hold the nails with my left, I like to start from the right side of the pattern and work toward the left. Tear off the pattern, using your needle-nose pliers to remove any leftover paper.

3 Decide which colors will go where before you start. I chose to lay my string from darkest to lightest, adding an ombré effect. Tie your first color onto a letter, making sure to seal the knot with glue as you go.

4 Start with the outline of your letter so it's easier to see where the string should go. If the letter shape isn't obvious, refer back to your pattern page.

5 Zigzag your string randomly through the letter. I used an entire skein of floss per letter. To keep the letter looking clean, add the double-wrap technique to the border. Don't forget to seal your ending knot.

6 Repeat steps 3–5 for the remaining letters.

7 Attach the two sets of picture-hanging hardware to the back, each 4" (10cm) from the side and 1" (2.5cm) from the top. Add felt pads to the lower corners on the back. Be sure to sign and date your work.

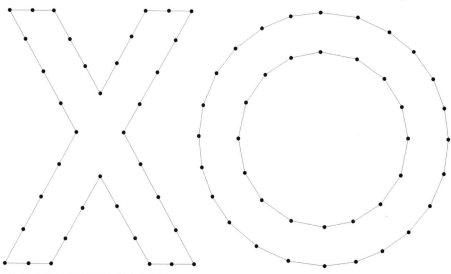

HUGS 'N KISSES PATTERN
Enlarge at 200%.

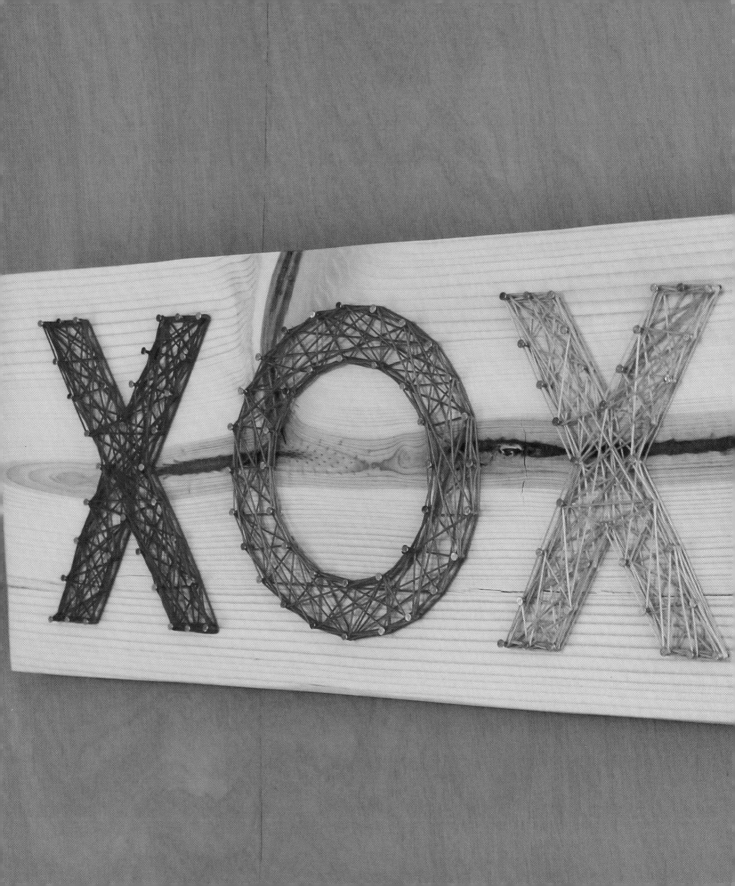

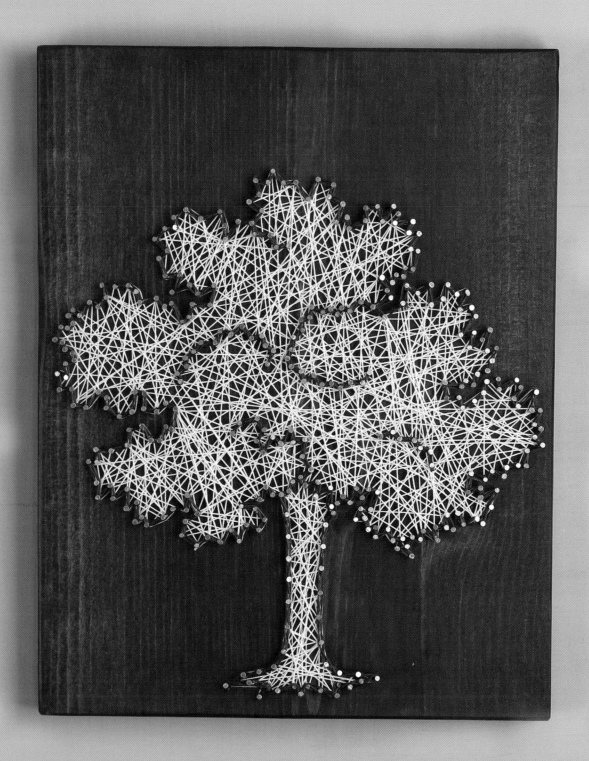

MAPLE TREE SILHOUETTE

DIFFICULTY:

The maple tree is one of my favorites and is a symbol of balance and promise. When designing the pattern, I added light foliage detail in the middle to add dimension. It's subtle but adds a nice touch. For this project, we'll be combining the silhouette, pattern expansion, and double-wrap techniques.

Materials

Pine board: 1" × 12" (2.5cm × 30.5cm), cut to 14" (35.5cm) long and stained (Shown: Minwax Wood Finish in Red Chestnut)

⅝" (1.6cm) silver nails

Size 10 crochet thread in 1 color (Shown: White)

Embroidery floss in 1 color (Shown: DMC 3787/Dark Brown Gray)

Photocopy of patterns (page 124)

Picture-hanging hardware

2 felt furniture pads

Tools: Hammer, needle-nose pliers

Basic supplies: Thumbtacks, superglue, scissors, transparent tape

Techniques Used

Preparing a board (page 8)

Applying a nail pattern (page 9)

Stringing basics (pages 10–11)

Double-wrap technique (page 13)

Finished Size (h × w)

14" × 11.5" (35.5cm × 29cm)

MAPLE TREE SILHOUETTE

1 Trim both your patterns, the treetop and the trunk, down to a more manageable size. Secure your tree top to the board with tape.

2 Using the thumbtack pattern expansion technique (see the *Triangle Tiles* project on page 88 for details), match the red dots of the trunk pattern with the red dots of the treetop pattern. Secure the trunk with tape.

3 Hammer your nails through the pattern. Remember, trees in nature aren't perfect, so if any nails are slightly off or crooked, it will only add to the realistic look. Remove the patterns and debris.

4 Outline your pattern with string. Refer to the pattern page to help you connect the right nails.

5 Now that you can see the overall shape, start with the fill. I chose to do both the treetop and trunk in white, though you can see it would be easy to do them using two separate colors. This takes a good amount of string, which is why I'm working with a spool of crochet thread. Zigzag across the pattern until you're happy with the density. You can cross over or attach to any of those nails in the center; they remain sort of invisible until we highlight them in the next step.

6 Follow up with the double-wrap outline. It's important in string art to do your outlining last, so it's on top of the fill and more noticeable. I chose a subtle brown and used two skeins of floss. Be sure to double-wrap the foliage detail nails in the center to really make them visible to the viewer. Two of the detail lines are not connected to the border, so you'll need to cut your string and do those separately. When tying on and off, be sure to seal all of your knots.

7 Attach your picture-hanging hardware and felt pads to the back. Sign and date your work and choose where to "plant" your tree.

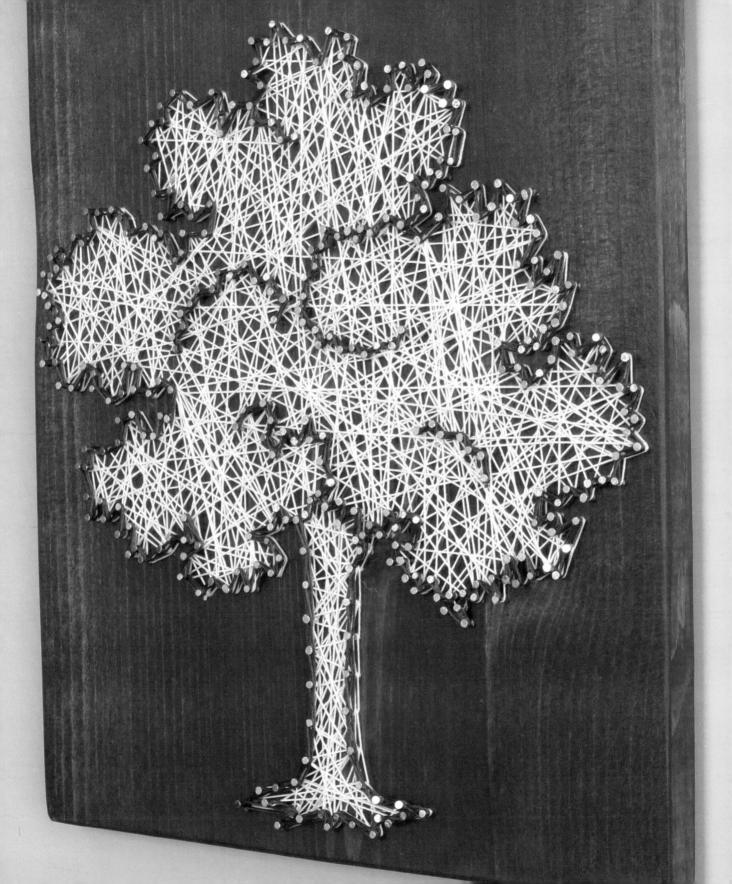

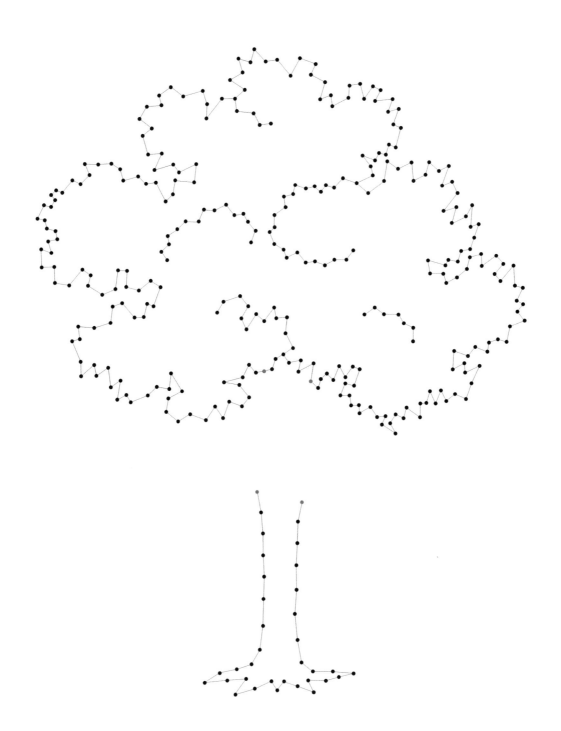

MAPLE TREE SILHOUETTE PATTERNS
Enlarge at 200%.

INDEX

Acquisition editor: Amelia Johanson
Editor: Stefanie Laufersweiler
Beauty photography: Alexandra Artiano
Step photography: Jesse Dresbach
Cover and interior design: Alexandra Artiano

20 19 18 17 16 5 4 3 2 1

www.fwcommunity.com

a content + ecommerce company

Distributed in Canada by Fraser Direct
100 Armstrong Avenue
Georgetown, ON, Canada L7G 5S4
Tel: (905) 877-4411

Distributed in the U.K. and Europe by
F&W MEDIA INTERNATIONAL
Brunel House, Newton Abbot, Devon, TQ12 4PU, England
Tel: (+44) 1626 323200, Fax: (+44) 1626 323319
E-mail: enquiries@fwmedia.com

Distributed in Australia by Capricorn Link
P.O. Box 704, S. Windsor NSW, 2756 Australia
Tel: (02) 4560 1600, Fax: (02) 4577 5288
E-mail: books@capricornlink.com.au

SRN: 16MM02
ISBN 978-1-63250-467-8 (pbk)

PDF SRN: EP13350
PDF ISBN 13: 978-1-63250-462-3

Metric Conversion Chart		
To convert	*to*	*multiply by*
Inches	Centimeters	2.54
Centimeters	Inches	0.4
Feet	Centimeters	30.5
Centimeters	Feet	0.03
Yards	Meters	0.9
Meters	Yards	1.1

ABOUT THE AUTHOR

Photo by Lisa Robinson
(lisarobinsonphotographer.com)

I'm Jesse Dresbach, I'm a Virgo, and I grew up in San Jose, California, getting myself into as many projects as I could find. To this day, I have very restless hands—I always need to be doing or making something creative. In 2006, I moved to Santa Cruz, California, where I started my blog *Nine Red* as a just-for-fun collection of projects and tutorials in a no-frills casual style. The blog led to an Etsy shop, where my most popular items have been, you guessed it—string art! I've been fortunate enough to have had so many interesting opportunities emerge out of all this, from massive-scale projects in San Francisco to this book. In 2012, my partner, Ralph, and I took the plunge and bought a home in Ben Lomond, California, where we officially became mountain men and spend our weekends working on the house, cruising around in our 1985 station wagon, and finding the best swimming holes in the San Lorenzo Valley. Visit my blog at NineRed.com and my online shop at NineRed.Etsy.com.

DEDICATION

I dedicate this book to my cats—they love string and so do I.
And also to the invention of the hammer, which really helped with the nails.

ACKNOWLEDGMENTS

I'd like to thank my family and friends for their support of my many, many wild projects over the years. Their input and encouragement have kept me going as I explore and try new things. I'd especially like to thank my partner, Ralph, for tolerating the many art-supply explosions that take over parts of our home for days at a time and for jumping into those projects with me. A huge thank-you to everyone at F+W for making this dream a reality, especially Amelia Johanson for seeing the book potential, Stefanie Laufersweiler for her editing genius, creative director Lis Lariviere, and designer Alexandra Artiano for making my work shine.

CREATE AND UNWIND

Stitch and De-stress with 40 Simple Patterns

Cross-Stitch to Calm
Stitch and De-stress with
40 Simple Patterns
Leah Lintz

For coloring book graduates, this crafts-meets-meditation approach contains simple cross-stitch patterns for stitching sessions that maximize fun and minimize stress. The repetitive nature of cross-stitching not only lets stitchers relax, restore, and clear their minds, it gives them a pretty piece to frame and admire when they're done. Calming words and mellow themes are featured in forty easy-to-stitch patterns.

Mollie Makes Papercraft
From Origami to Greeting Cards and Gift Wrap,
20 Paper Projects for You to Make
Mollie Makes Editors

The *Mollie Makes* magazine brings together the best in paper-crafting in a range of impressive projects from paper-cutting to papier-mâché to paper flowers and more. Featuring fifteen projects that are easy to execute but never ordinary!